COLLINS • Learn to draw

Fantasy Art

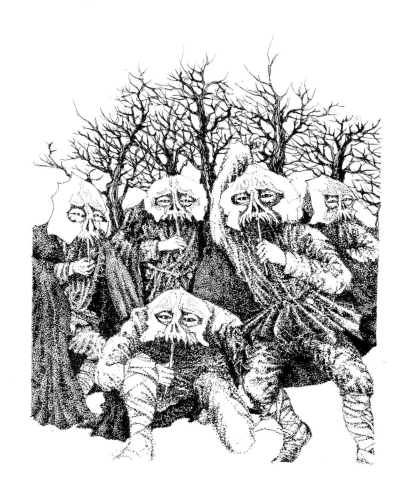

MIKE JEFFERIES

Other titles by Mike Jefferies
available from HarperCollins

THE ROAD TO UNDERFALL
PALACE OF KINGS
SHADOWLIGHT
THE KNIGHTS OF CAWDOR
CITADEL OF SHADOWS
CHILDREN OF THE FLAME

The map on page 60 is taken from
Warhost of Vastmark –
The Wars of Light and Shadows: Volume 3
by Janny Wurts,
and is reproduced by kind permission of the author.

First published in 1997 by
HarperCollins*Publishers*
77-85 Fulham Palace Road
Hammersmith, London W6 8JB

The HarperCollins website address is:
www.**fireandwater**.com

Collins is a registered trademark
of HarperCollins Publishers Limited.

02 04 06 07 05 03 01
6 8 10 11 9 7 5

© HarperCollins Publishers 1997

Produced by Kingfisher Design, London
Editor: Diana Craig
Art Director: Pedro Prá-Lopez
Designers: Frances Prá-Lopez, Frank Landamore

Contributing artist: Janny Wurts *(page 60)*
Contributing photographer: Mark Nicholson *(page 62)*

A catalogue record for this book is available from the British Library

ISBN 0 00 413358 7

Printed by Midas Printing Ltd in Hong Kong

CONTENTS

Introduction 4

Tools and Equipment 6

Choosing the Right Medium 14

Fantasy People 16

Figures in Action 18

Proportion and Shape 20

Costumes and Props 22

Fantasy Beasts 26

Fantasy Birds 30

Looking at Features 32

Magical Trees 36

Angels and Demons 38

Wizards and Magicians 40

Movement 42

Sketching 44

Castles and Citadels 46

Chariots and Galleons 50

Drama and Atmosphere 52

In Setting 58

Creating Maps 60

Working from References 62

Introduction

I am often told that I am so lucky to be able to draw, that having a vivid, fertile imagination is a real gift. But I am not so sure if that is the truth. Drawing, like most things we do, requires practice – lots of it – and as for that fertile imagination I am sure that it wouldn't be half so good without regular use.

Persistence and practice has more to do with my ability to draw than luck or any other extraordinary quirks of nature usually attributed to creative people. But it did start somewhere. As I remember it, almost everyone in my class at school used to let the fantasy characters who crowded their imaginations escape through the tips of their pens or the points of their pencils to march unchecked in chaos across the margins of their exercise books or obliterate the important messages that somebody else had jotted down on the telephone pad. I was not the best in my class at school but I did persist with my drawing, developing and expanding the basic skills I learned both in a visual and literal way to write and illustrate my 10 fantasy novels that have been published by HarperCollins to date.

'I wish I could do that ... but it's far too difficult,' I hear you say. But I bet you haven't forgotten how to hold the pencil and you can still conjure up in your imagination those pictures from childhood as you delve into your favourite fantasy books. So let us bring the heroes and villains from those stories to life. Let me lead you through the step-by-step instructions.

Tools and Equipment

Before we delve into fantasy art, the first thing we have to do is to select what we are going to use to bring these fantasy figures to life.

Pencils

A pencil is probably one of the first tools you ever used to draw with as a child and is still one of the most versatile tools. Pencils can be bought with a variety of different leads, from the softest – 9B – which produces a very thick, dark line, to the hardest, a 9H. HB is a medium-grade pencil and the softer B grades can be used for tonal variations. Remember, the softer the pencil, the easier it can be erased, but the easier it is to smudge, too. So, if you do use pencil, it is a good idea to spray your drawings with a fixative to preserve them.

Having decided to use pencils there are a number of different forms to chose from. There are clutch and propelling pencils which come in many varieties of hardness and softness and save the need for continually sharpening the lead. There are coloured pencils, and there are also watercolour pencils which can look very like paint when softened with a wash of water.

You should experiment with as many types of pencil as possible and discover which ones help you to produce the effect you are looking for.

For this drawing I used pen and ink on smooth cartridge paper. This is a good medium for fine detail.

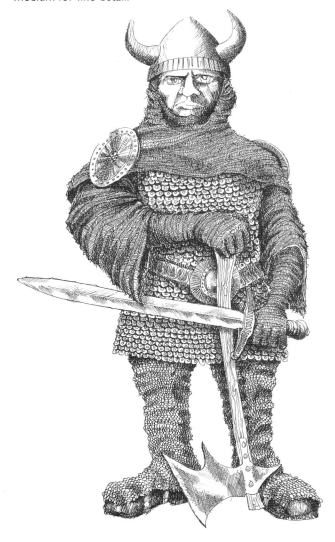

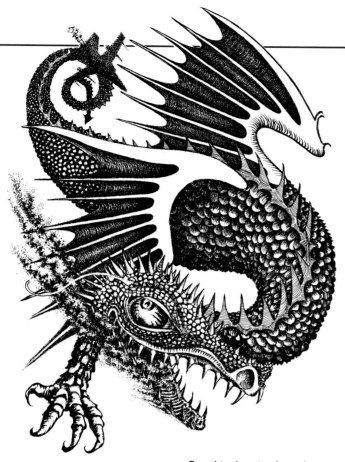

For this drawing I used a technical pen on line and wash board.

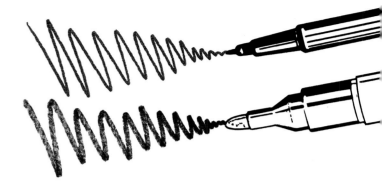

Pens

There are various different types of pen, each giving an entirely different style.

Ballpoint pens are something we have all doodled with. They are cheap and easy to use but they do not offer much scope with their rigid point and unchanging line. They are also inclined to smudge and leave inky blobs.

Technical drawing pens are excellent for neat, precise drawings, perhaps of buildings or other objects needing sharp definition. They also come in a large range of widths which can enable you to produce a number of different effects.

Fountain pens also offer a number of different nib widths, and by altering the pressure applied you can produce a variety of line. Although you can still buy the old-fashioned dip type there are newer types which can use cartridges and so prevent the need to refill every few minutes.

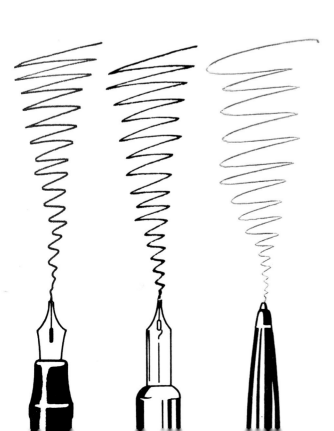

Artist's Tip

Get richness and variety into your work by using different grades of pencil and different types of pen in the same drawing.

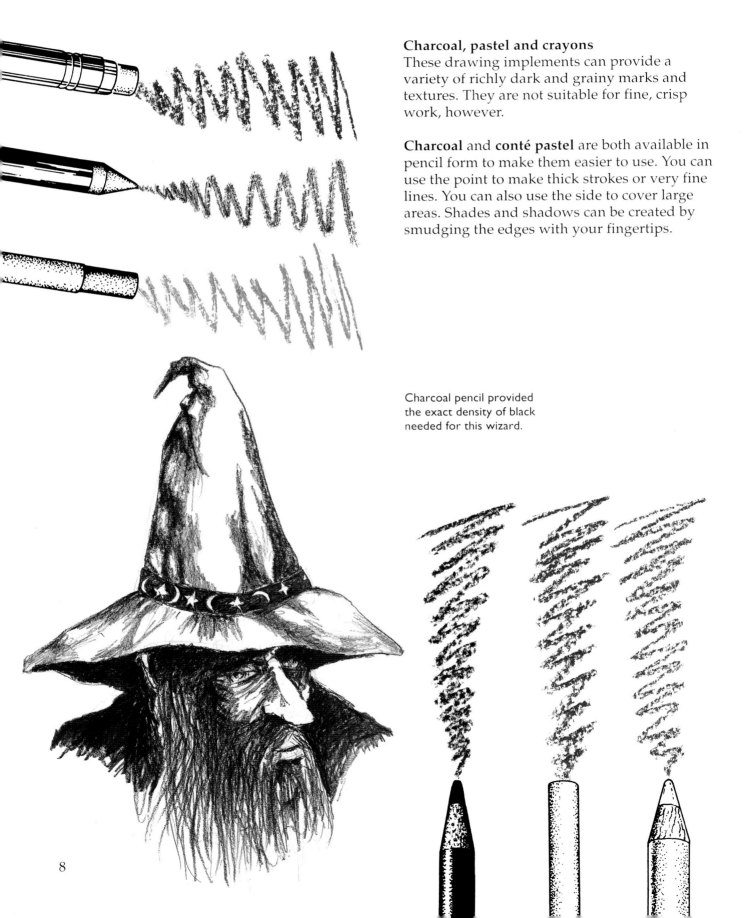

Charcoal, pastel and crayons

These drawing implements can provide a variety of richly dark and grainy marks and textures. They are not suitable for fine, crisp work, however.

Charcoal and **conté pastel** are both available in pencil form to make them easier to use. You can use the point to make thick strokes or very fine lines. You can also use the side to cover large areas. Shades and shadows can be created by smudging the edges with your fingertips.

Charcoal pencil provided the exact density of black needed for this wizard.

A putty eraser is a helpful tool to have at hand when you are working in charcoal. You can use it to blend one area into another to create a soft, blurred effect, or to lift out highlights in the darker parts of your picture.

Oil pastels and **wax crayons** come in a large number of colours. Their greasy consistency makes them very difficult to erase, so it is a good idea to plan your picture carefully before you start to use either of these.

Artist's Tip

While working with media that might smudge, rest your hand on a piece of paper to protect areas already completed and spray with a fixative once the picture is finished.

This drawing of castle battlements was done in oil pastel thinned with turpentine. The effect is similar to that of watercolour.

Brushes and wet media

Wet media can be used in combination with line drawings to add tone and depth.

Oil paints are very expensive, slow-drying and require skill to achieve the best results. Water-based paints are easier to handle and much more convenient.

Watercolours can be used to give gentle tone and transparent washes or, if you use less water, can produce strong colours. They can be very effective when used in conjuction with pen and ink or pencil drawings.

Gouache is a type of watercolour, but with a more opaque quality.

3

5

4

6

3 For an even layer of strong watercolour, add darker washes to a light wash while still wet.

4 To prevent colours 'bleeding' into each other, let the first layer dry before adding the next.

5 For a soft, blurry effect, paint watercolour onto paper that has been slightly dampened.

6 Ink or concentrated watercolour on damp paper will spread into swirls and blotches.

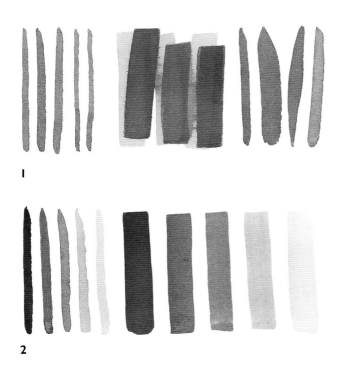

1

2

1 These brushmarks were made with *(from left to right)* a small, pointed brush; a flat brush; and a large, pointed brush.

2 Watercolour tone can be progressively reduced by adding more water, as shown by these strokes using different dilutions.

Acrylic paints can be used as watercolours but if used undiluted can look almost like oils, with far less trouble.

Brushes can be used to add colour or tone to large and small areas and there are a vast array of sizes and types for sale. Sable is the best-quality hair to use in a watercolour brush. It is expensive but long-lasting and will give excellent results. Squirrel hair or synthetic fibres are cheaper, so experiment and see which works best for your style.

As well as brushes, you will need a palette on which to mix the colours and two jam jars – one containing water to mix the colours and one for washing your brushes.

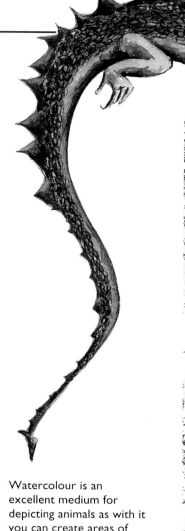

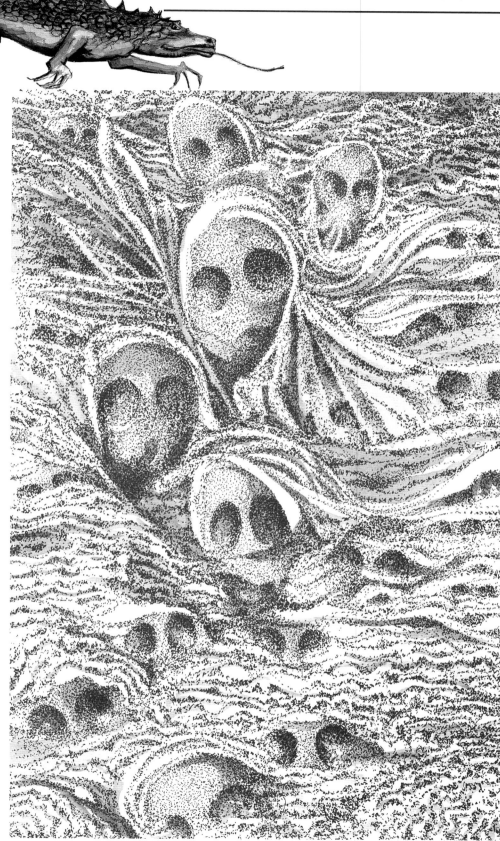

Watercolour is an excellent medium for depicting animals as with it you can create areas of soft, delicate colour *(above)*.

To create the impression of these ghostly shapes *(right)*, I used a pen-and-ink stipple overlaid with a thin watercolour wash.

Artist's Tip

Brushes need washing, especially after use with waterproof inks. They deteriorate quickly if left standing in water.

Newsprint is very inexpensive, which makes it good for practising and rough sketching.

Tracing paper is semi-transparent, so that you can lay it over other images and trace them.

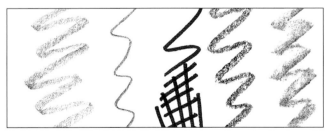

Stationery paper, usually available in one size, has a hard, smooth surface that works well with pen.

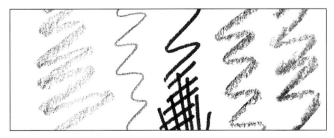

Cartridge paper usually has a slightly textured surface, and is one of the most versatile surfaces.

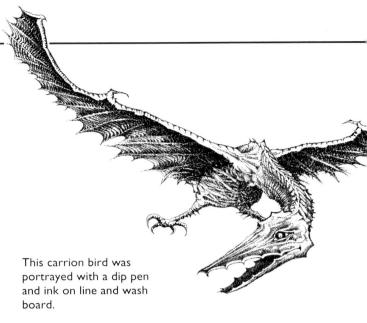

This carrion bird was portrayed with a dip pen and ink on line and wash board.

Surfaces

Your choice of surface will make a considerable difference to the finished product. Experiment and see what suits you best. Different combinations of paper and drawing tools can radically alter what you are trying to portray.

Some papers, however, are unsuitable for certain media. You will find that pen and ink does not work well on heavily textured paper, and chalk or crayon works less well on smooth paper. On the whole, smooth surfaces work best for pen and wash and all very detailed work, while the rougher-surfaced paper suits bold pencil, charcoal and crayon.

The manufacturing process produces paper with one of three grades of surface: *hot-pressed* (smooth), *not* (not hot-pressed, and slightly rough), and *rough* (textured).

Watercolour paper is the most expensive paper. It comes in different thicknesses, measured by weight. It is very tough, thick and absorbent in order to hold watercolour, which can be a very watery medium. It is not wholly made of paper; included in its composition is cotton and/or linen. It is excellent for washes and is acid-free so it will not go brown when left exposed to daylight. Watercolour paper often has attractive textures, called 'laid' or 'wove', according to the mould in which it has been made.

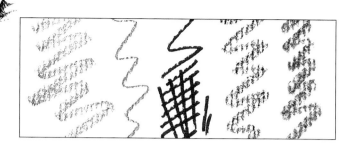

Ingres paper, in various colours and with a lightly ridged surfce, is ideal for pastel and charcoal.

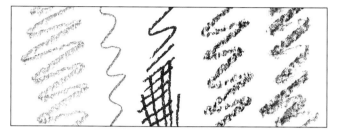

Watercolour paper is thick and absorbent, and has a rough surface. It is good for wet media.

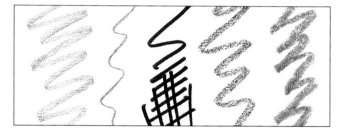

Bristol board is stiff and has a smooth surface that makes it a good surface for pen drawings.

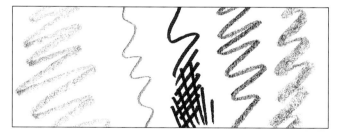

Layout paper is a semi-opaque, lightweight paper that is very suitable for pen or pencil drawings.

Cartridge paper is the most useful surface for day-to-day drawing. It is available in either cream or white and comes in sheets or rolls, so you can buy it in small quantities or in bulk. It has a slightly textured surface which makes it one of the most versatile surfaces for many different sorts of drawing.

Blocks, books and **pads** are usually made of cartridge paper. They are very useful for keeping your work together, and also for outdoor sketching – although it is unlikely that you will find exactly what you are trying to express in the High Street. Many ordinary things, however, are ideal for initial inspiration.

Stationery paper is usually only available in one size but it works well with a pencil or a pen. The same applies to photocopying paper.

Tracing paper is not a surface for a finished drawing, but it is useful to have. Don't be afraid to 'borrow' other images that you have seen, tracing them from books or magazines, for example, if you think this will improve your finished picture. The transparency of tracing paper also means that you can use it for preliminary sketches, and then overlay your sketches on top of each other to find the most pleasing composition.

I used soft 2B and 4B pencils on cartridge paper, adding a heavy shadow in the background, to create the brooding atmosphere that this creature of the night evokes.

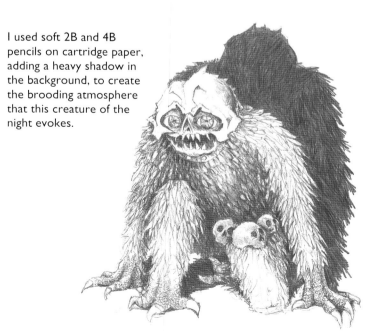

Choosing the Right Medium

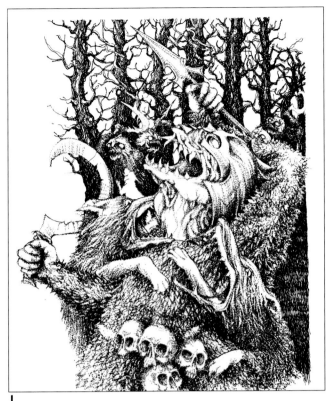

1

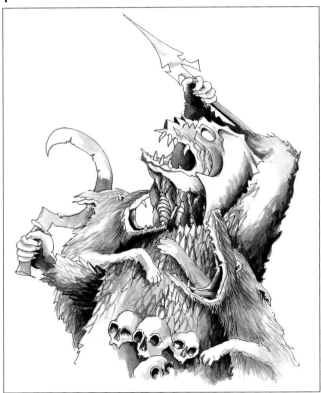

2

It is worth spending time trying your hand at as many different types of media and surfaces as possible, first to get the feel of working with them and second, and perhaps more importantly, to discover which ones suit your style of drawing best.

The medium you choose is often dictated by the subject matter of your drawing. For example, a drawing requiring a lot of detail is probably better done in crisp pencil or pen and ink, while watercolour or ink and wash drawing is highly effective for portraying light and shade, or soft detail. A picture with lots of movement often works best if done in charcoal, or on a textured paper. Sometimes mixing different media together can give startling effects.

There is one last and very important reason for experimenting with different media. It is time you wrestled with the ink-blot goblin who is lurking inside the nib of your pen, or take up battle with the smudger who hides inside every stick of charcoal just waiting to spoil your work.

On these two pages I have produced six different drawings of an identical scene, showing a fantasy creature being attacked by savage dogs. The combination of different media and surfaces has dramatically altered the atmosphere and impact of the subject matter in each picture … and there are no extra marks for spotting the deliberate mistake.

1 Pen and ink on line and wash board

2 Pen-and-ink wash on smooth cartridge paper

3 Watercolour on rough watercolour paper

4 Coloured pencil on rough textured paper

5 2B and 4B pencil on smooth cartridge paper

6 Charcoal on rough textured paper

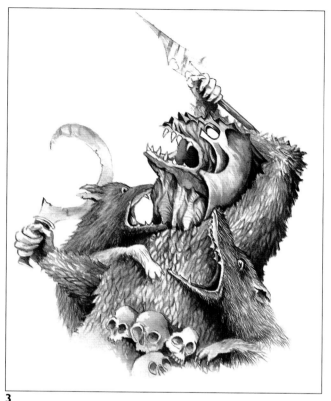

3

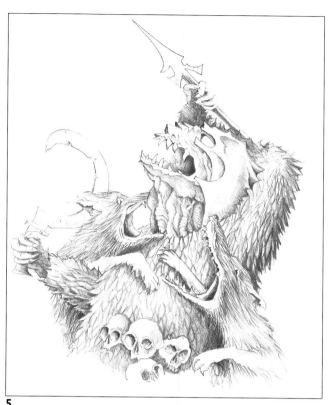

5

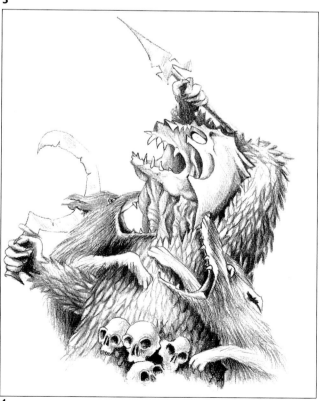

4

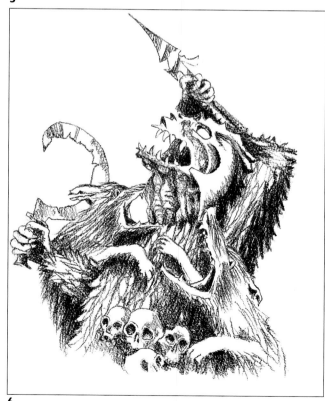

6

Fantasy People

A little anatomical knowledge, although not essential, will be a great help in understanding how the main parts of the body work, and how the head and neck, and the torso and limbs articulate together.

Fantasy figures, of course, both human and non-human, are in a category of their own; they do not have to follow these underlying anatomical rules. However, most of your characters – no matter how weird and wonderful – will benefit from having an underlying skeletal structure, even if it is a very simple one.

Matching halves

A good point to remember is that the human skeleton can be divided vertically through the spinal column and the bones on either side will always 'match'. So whatever the arms and legs are doing they should always have corresponding proportions.

Here I have attempted to show how the skeleton changes as it is rotated. Note how the angle of the spine changes, and with it the position of the collar bones and pelvis. Note, too, the position of the knees and elbows as the arms move.

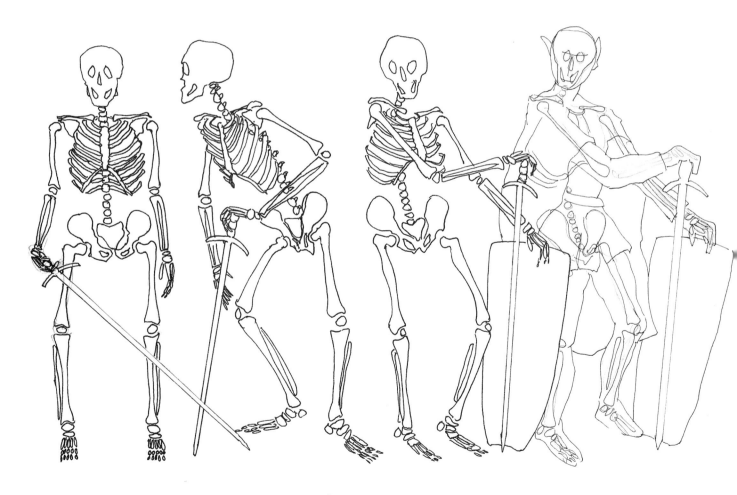

These animated skeletons (*above*) were drawn with a technical pen on white cartridge paper. Once the skeleton was rotated into the desired position, I began to flesh it out into the elfin warrior you see opposite.

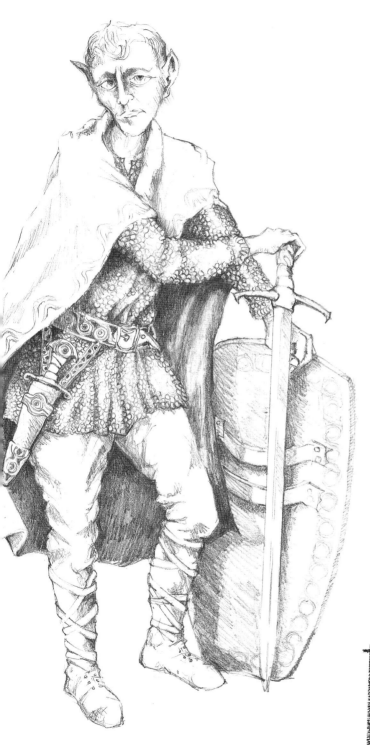

Starting with the skeleton

Having decided upon your subject matter, lightly sketch in the skeleton. A few moments spent roughing this in will help you to portray realistic movement. It is useful to remember that the bones that are close to the surface of the skin – the elbow, wrist, knee and ankle joints – are always visible.

Fleshing the skeleton

I have decided to draw an elfin warrior for you using the position of the skeletal study. In my fourth pen sketch, I have fleshed out the bones and marked where the nose and eyes will be. I have also indicated the cloak and the mail shirt that the warrior will be wearing.

Finishing touches

In my final drawing of the elf warrior, I have lengthened his ears and given him a serious but pensive face. I have also added the detail of the chainmail links on his shirt and drawn in a dagger. Note the use of the dramatic, heavy shadow inside his cloak which adds depth to the study.

I used an HB pencil for the detail on the chainmail shirt, and 2B and 4B pencils for the heavier shading.

Artist's Tip

It is best to sketch in the position of the spine, the head and the angles of the arms and legs before putting flesh to the skeleton.

Figures in Action

With figures in dramatic positions it is important to get the angles and position of the subject right in the basic sketch.

The right pose
Before making a start on this pen drawing of a figure being attacked with spears, I had to make sure that I had the correct angle of the spine and the proper distribution of the figure's weight in the right place. He is retreating but about to fight back so I had to make him look directly at his attackers. Note the lines sketched in for his eyes, nose and mouth. The second pencil sketch was done to establish the drama of the moment through light and shadow.

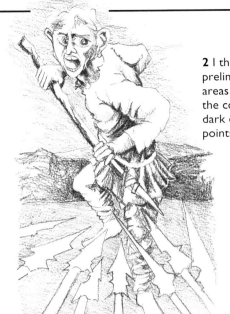

2 I then worked into my preliminary drawing, adding areas of shade. Note how the contrasts of light and dark emphasize the focal points of the picture.

1 I began with this sketch showing the essentials; the angles of parts of the body, and where the weight falls.

Although adding in the tiny details may be the most enjoyable part of your drawing, don't get bogged down in it too soon. Your drawing won't work if you don't get the basics right first.

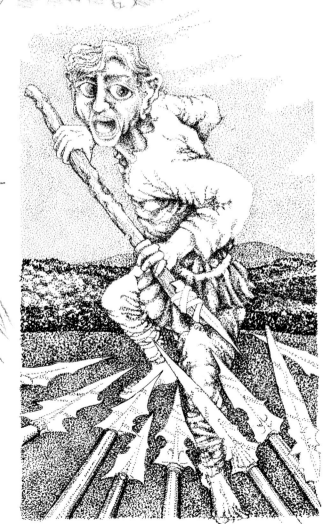

3 This is where the fun begins. Having established the basic forms and tones, I was able to concentrate on filling in the details, using lines and stippled dots.

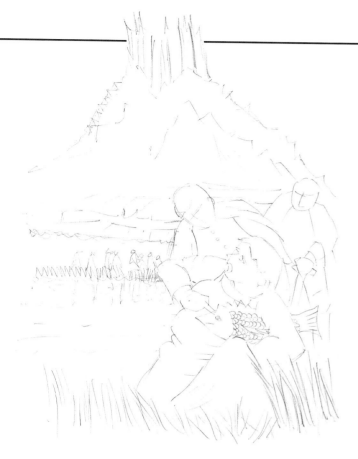

Adding backgrounds

Placing your action figures against a background can heighten the drama of the moment. The background you decide upon is as important as the people themselves and, obviously, it must relate to the fantasy figures you are depicting. In this example, I have chosen a pen-and-wash illustration from my book *Glitterspike Hall*.

Begin by deciding where you want the centre of action to be. In my drawing, placing the action off to one side emphasizes its 'secrecy' and the figure's shock at being discovered. In the second sketch, I sorted out the tonal values: it is important to do this before starting on the final drawing. Finally, I added a line of people on the far side of the marsh holding fishing baskets to draw your eye – a peaceful scene contrasting with the excitement in the foreground.

1 In my preliminary sketch *(above)*, I have placed the centre of action in the front right-hand side of the picture.

2 Using pen and wash, I then determined the main areas of light and shadow *(below)*.

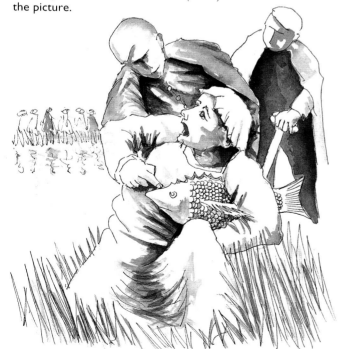

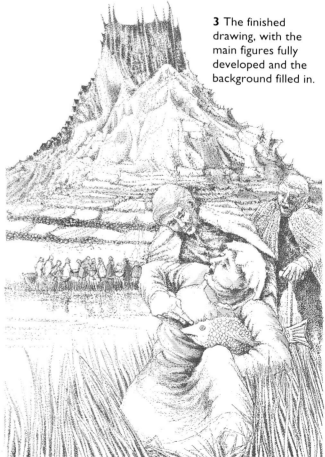

3 The finished drawing, with the main figures fully developed and the background filled in.

Proportion and Shape

This section is intended to show the proportions of the human figure and demonstrate a simple method of drawing a grid to measure people.

If you measure the length of the head in an adult you will find that it divides into the body seven times; for a child this will be four times. The adult torso is three head-lengths and the upper and lower legs are approximately two head-lengths. Children, however, have a torso that is two head-lengths, and the upper and lower legs are one head-length each.

All shapes and sizes

I had no sooner set pencil to paper to explain this visually for you before some of the fantasy figures who inhabit the shadowy corners of my studio crowded forwards to see what I was doing. There was a lot of muttering about generalization and they wished to know exactly where they fitted into these measurements. Eventually it was agreed that, rather like trying to squeeze into Cinderella's shoe, their shapes and proportions would not quite fit into my grid.

As you can see from quick sketches that I have managed to capture of them, their heads are sometimes larger and their torsos longer or more squat and rounded than those of ordinary humans. Their arms and legs can also be larger while their feet are often quite different in shape and proportion.

HB pencil on smooth cartridge paper was used in this drawing. To create a dramatic atmosphere, I erased the pencilled area around the lantern.

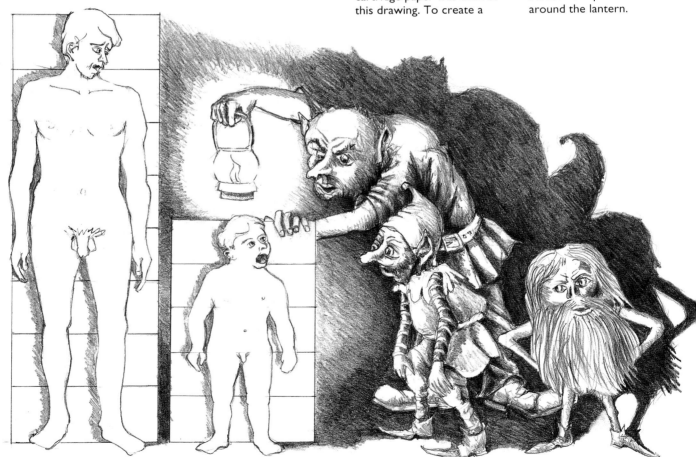

Larger than life

In the case of the giant on this page who is stealing away with an elfin child (how can I say this without him overhearing and taking offence?) his proportions and features are much coarser, to the extent that he looks almost clumsy and raw-boned.

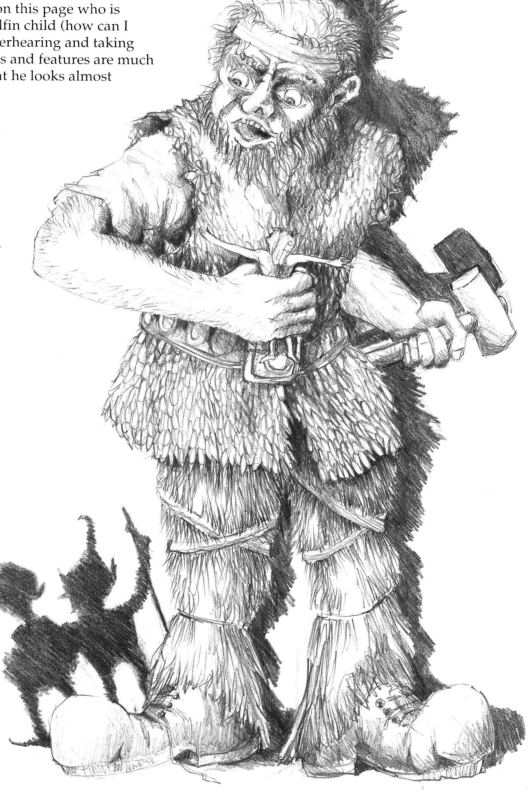

Artist's Tip

Lightly sketch in the proportion lines before paying attention to detail in individual figures.

Bold strokes with a soft pencil created this picture and dense shading gives the impression of two figures standing behind him.

Costumes and Props

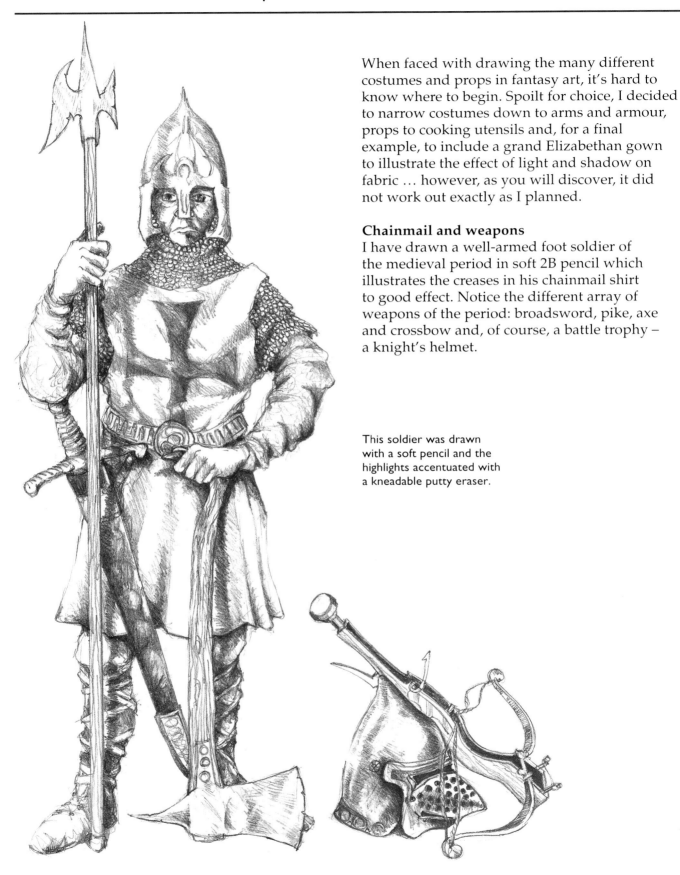

When faced with drawing the many different costumes and props in fantasy art, it's hard to know where to begin. Spoilt for choice, I decided to narrow costumes down to arms and armour, props to cooking utensils and, for a final example, to include a grand Elizabethan gown to illustrate the effect of light and shadow on fabric … however, as you will discover, it did not work out exactly as I planned.

Chainmail and weapons

I have drawn a well-armed foot soldier of the medieval period in soft 2B pencil which illustrates the creases in his chainmail shirt to good effect. Notice the different array of weapons of the period: broadsword, pike, axe and crossbow and, of course, a battle trophy – a knight's helmet.

This soldier was drawn with a soft pencil and the highlights accentuated with a kneadable putty eraser.

Knight in armour

On this page I have used watercolour to complete my line drawing of a mounted knight in full armour. Watercolour is an excellent medium for showing light and the reflections on polished metal surfaces such as armour.

The small pencil sketch of the piece of half-armour illustrates how to begin a drawing of this type. Note how the openings for the arms and neck have been divided both vertically and horizontally to help to shape them correctly.

In this drawing *(right)*, note how the rider is sitting very squarely in the saddle, and how the weight of his legs is taken on the ball of the foot in the stirrup.

1 & 2 Watercolour is a very versatile medium for creating light and shadow. The fine etching on the armour was done with a slightly dry, fine brush after the picture was drawn *(below)*.

The watercolour sketch of the piece of half-armour shows how the light falls and reflects from a smooth metal surface. Small sketches like this one are useful for getting the feel of painting armour before attempting the more complicated picture such as the mounted knight.

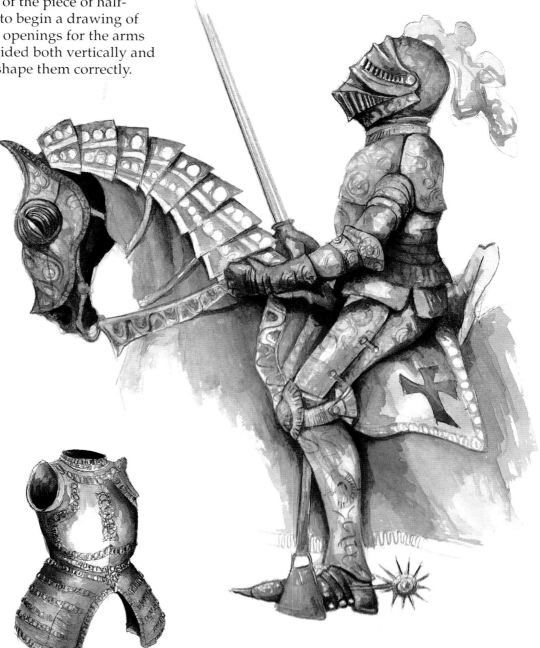

Mediaeval cooking pot

As an example of a prop, I have chosen this rather beautiful cooking vessel from the Middle Ages because it will give me the opportunity to unravel some of the secrets about drawing round or cylindrical objects, which even practised artists can find difficult.

Rule number one is observation. Look carefully at the object you wish to draw. Is it taller than it is wide? What are its overall proportions? The cooking pot I have drawn for you was designed to hang over a fire by a trammell chain and hook. The belly of the pot is wider than the rim and if we were to look directly down into it we would see two circles: the outer, wider circle of the side of the pot with the spouts and the one which forms the top rim where the handle fits. If we view the pot from the side, the circle of the rim appears to flatten and become an ellipse. This is an illusion: in reality the rim will still be a perfect circle.

The effect of perspective

At the top of this page, you can see how to draw a basic ellipse. However, perspective (which makes objects appear smaller the further away they are) can affect the symmetry of an ellipse, 'flattening' the arc furthest away and making it seem narrower than the one in the front.

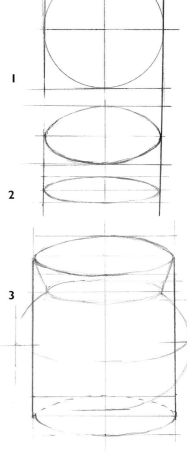

1 & 2 To create an ellipse, first divide a circle equally into four squares *(top right)*. Then reduce the four squares to rectangles, keeping the same central line. Draw four equal arcs in each *(right)*. Widen or narrow the rectangles to create ellipses of different sizes.

3 Using the same principle, you can then work out the ellipses that underlie any rounded form, such as this cooking pot *(right)*. Remember that all the ellipses will be the same width and depth.

1 & 2 Adding spouts and a handle to a basic form creates the finished pot *(below)*, drawn with soft pencil on cartridge board. Highlights have been lifted out with a putty eraser.

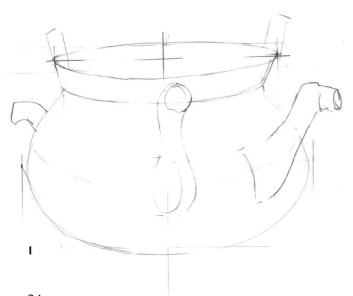

1

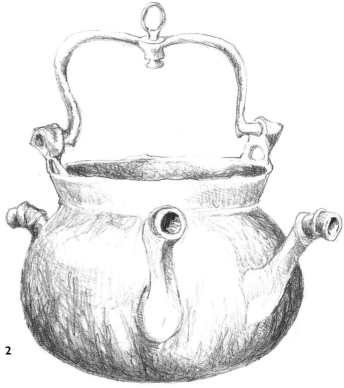

2

From robes to rags

Both in my written work and my illustrations, my characters have a sneaky habit of coming to life at the most unexpected moments, tampering with the plot whenever it takes their fancy – and this is exactly what happened on this page. One minute the outline of a tall woman in an Elizabethan gown was slipping off the end of my 4B pencil, the next minute I blinked and she had transformed herself into the macabre figure of Death you see here, dancing to the drumming of a musical companion.

All is not lost, however. The grave rags that cling to Death's skeletal body amply illustrate the way shadows form in the folds of a robe or gown.

Note the movement created in this figure. It is slightly off the vertical and is twisting round on the back foot. I did this drawing in 4B pencil on white cartidge paper.

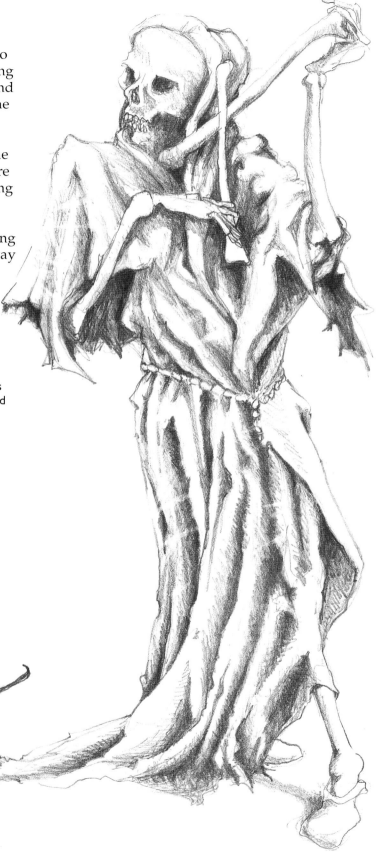

Fantasy Beasts

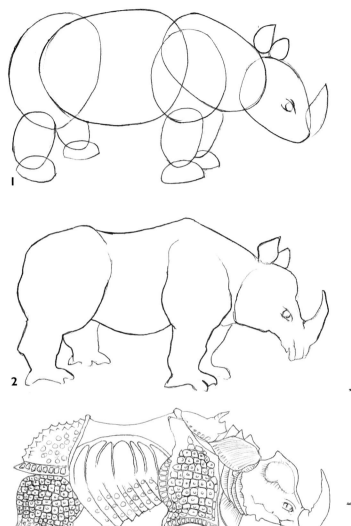

The variety of subject matter for drawing beasts is endless and the reference material available vast. I have chosen to draw an armoured rhinoceros in the style of the artist Dürer to illustrate how easy it is to turn such a ponderous beast into a creature of war in your fantasies.

Armourplating
When you come to adding the details of the armour, you may find it easier to draw these on tracing paper first which will allow you to experiment. You can then place the sketch of the armour over your refined sketch of the animal to see how they work together before doing your final drawing.

In my drawing of a fantasy rhino, I have placed scaly plates over the upper legs and a large moving piece of armour across the body as well as small moving pieces around the neck. The result is a pretty fearsome creature.

Artist's Tip

Do not make all of an animal's scales identical; they always vary slightly in shape and size.

1 First, I broke the mass down into its basic forms.

2 I then refined the animal's anatomical shape.

3 I worked out the shapes and detail of the armature.

4 The completed drawing of my fantasy beast. I have paid particular attention to the shading to give the rhinoceros the impression of great weight.

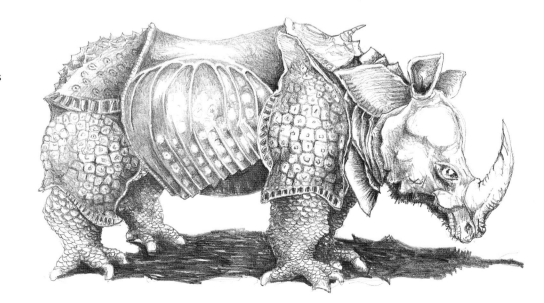

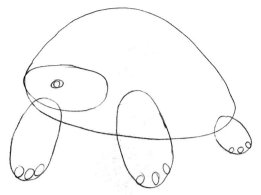

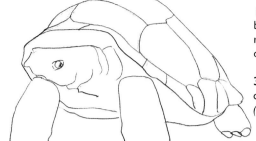

1 & 2 I sketched in the basic shapes *(far left)*, then refined them, adding some detail *(left)*.

3 Shading and detail completed my tortoise *(below)*.

From reality to fantasy

For my second beast, I have transformed a humble tortoise into a creature from your nightmares. Before starting on your fantasy animal, it's wise to give a few moments' thought to what you wish this creature to become. In this case, a slow-moving herbivore – the tortoise – is going to be metamorphosed into a fast-moving carnivore. The legs will need to be lengthened and jointed differently to give it speed, and its head and neck enlarged. It will also need sharp teeth.

Like the tortoise, the skin of the fantasy creature in the final drawing has a scaly texture. To achieve this, first lightly draw in the guidelines for the direction of the scales, making sure that they are not too uniform.

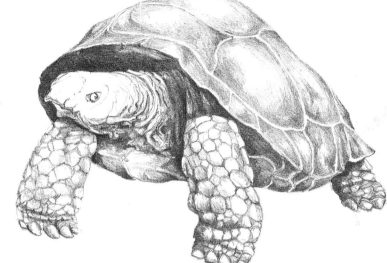

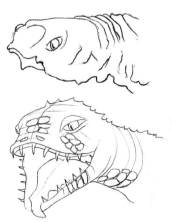

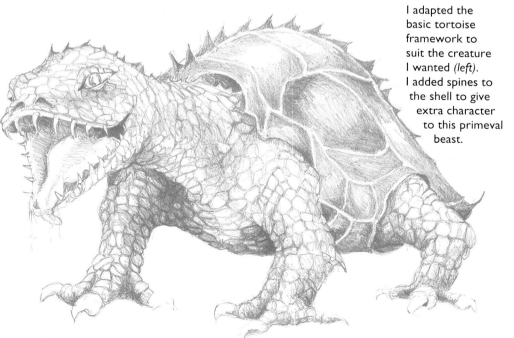

I adapted the basic tortoise framework to suit the creature I wanted *(left)*. I added spines to the shell to give extra character to this primeval beast.

Compare the fantasy beast's head with that of the tortoise: note how it has been enlarged and the neck extended *(above)*.

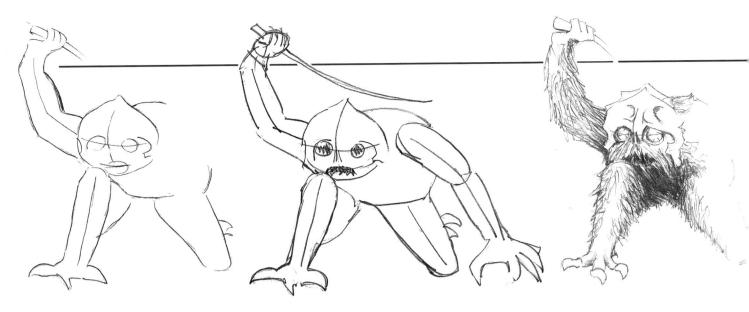

Animal or human?

The beasts on these two pages are based on the human form and show how slight anatomical changes can result in a rather frightening effect.

To develop such figures, first sketch in your basic shape and then pull around the proportions until you can see the creature that you wish to create. Before drawing the figures in their final position you may find it helpful to draw the spine, legs and arms so that you can establish their posture.

The figure above is a brooding presence. His torso is foreshortened, the head bent down below the top of his right knee. In the final group, he crouches behind the others, ready to spring forwards.

1 & 2 I built up my figure from a basic outline, showing the main angles and curves of the body.

3 Once I had established my figure, I was able to work in such details as hair and facial features.

The figure below appears more frightening because I have made him appear to be rushing towards the reader. To create this effect, make sure that the body mass is centred over the front foot. Note the directional lines down through the body.

The body of the figure shown at the top of the opposite page has been compressed and the shape of the head pushed down slightly into the body. The effect gives an impression of great strength. To add to the figure's ferocity a string of skulls has been sketched in around its waist.

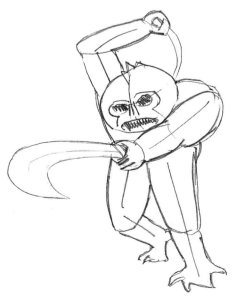

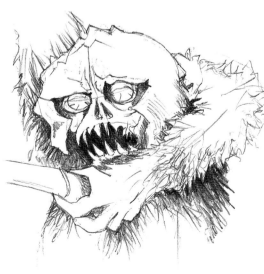

1 Note the construction lines that underlie the preliminary drawing of this beast *(far left)*.

2 You may find it helpful to make preparatory sketches of hands in the position you will be using in the final drawing *(left)*.

Grisly group

Having decided on the posture of your creatures, they can be lightly sketched in for the final composition. In my drawings on these two pages, I have made the heads basically circular and lightly drawn in the positions of the creatures' eyes, noses and mouths. To add to their menace, I have enlarged their mouths and crowded them with sharp teeth. They also wear a gruesome skull cap made from hard, dried animal skin which covers the top of their heads and part of their faces, rather like armour. Their eyes are staring and without pupils.

To make the creatures look even less human, I have given their skins a scaly, almost armoured appearance and have covered their legs in coarse hair. This texture can be achieved with a soft pencil following the contours of the limbs. Note that the final composition has been drawn in pen and ink with strong textured shading to highlight the 'scare' factor.

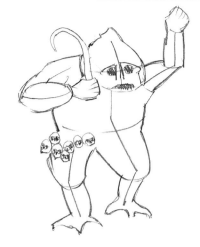

1 My initial sketch included all the basic information I needed *(left)*.

2 A bold pumpkin shape was used to achieve a good, strong structure for this creature's head inside its helmet *(below left)*.

3 Details of the teeth and eyes were added last, along with the heavy shading inside the mouth *(below)*.

 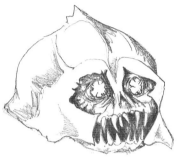

When I was happy with my three basic figures, I was able to combine them in this group.

Artist's Tip

Attention to the depth of light and shadow helps to create the atmosphere in your picture.

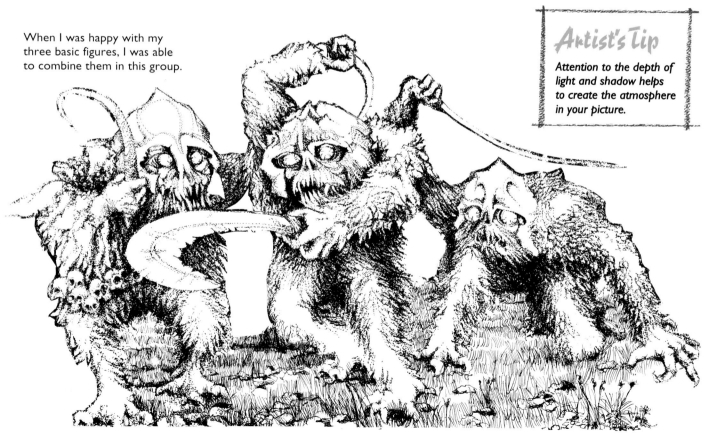

Fantasy Birds

Birds of prey and carrion frequently appear in fantasy. Here I have created two such birds. Anatomically the one on the right is a cross between an eagle and a vulture with a little bit of bat thrown in for good measure, while the one opposite is reminiscent of a pterodactyl.

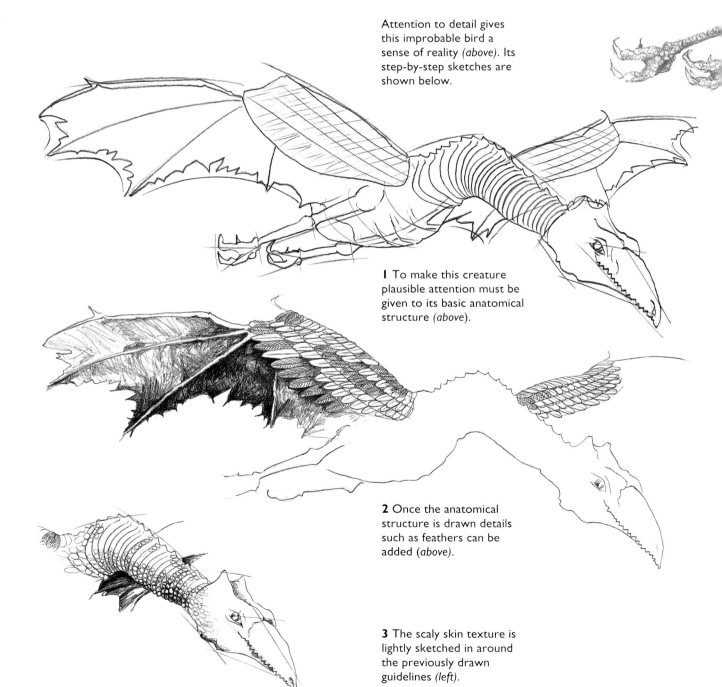

Attention to detail gives this improbable bird a sense of reality *(above)*. Its step-by-step sketches are shown below.

1 To make this creature plausible attention must be given to its basic anatomical structure *(above)*.

2 Once the anatomical structure is drawn details such as feathers can be added *(above)*.

3 The scaly skin texture is lightly sketched in around the previously drawn guidelines *(left)*.

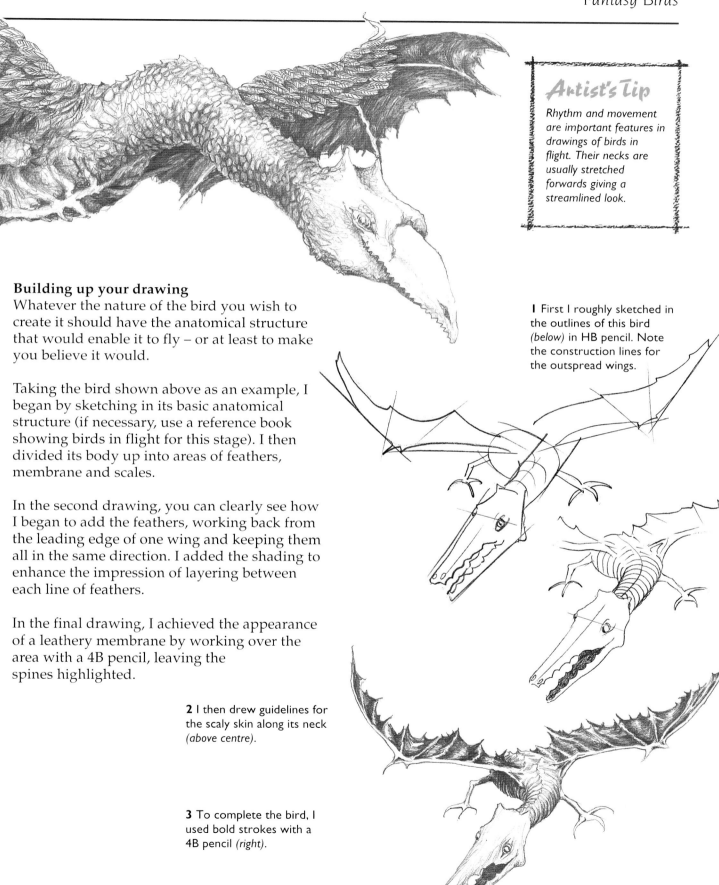

Artist's Tip

Rhythm and movement are important features in drawings of birds in flight. Their necks are usually stretched forwards giving a streamlined look.

Building up your drawing

Whatever the nature of the bird you wish to create it should have the anatomical structure that would enable it to fly – or at least to make you believe it would.

Taking the bird shown above as an example, I began by sketching in its basic anatomical structure (if necessary, use a reference book showing birds in flight for this stage). I then divided its body up into areas of feathers, membrane and scales.

In the second drawing, you can clearly see how I began to add the feathers, working back from the leading edge of one wing and keeping them all in the same direction. I added the shading to enhance the impression of layering between each line of feathers.

In the final drawing, I achieved the appearance of a leathery membrane by working over the area with a 4B pencil, leaving the spines highlighted.

1 First I roughly sketched in the outlines of this bird *(below)* in HB pencil. Note the construction lines for the outspread wings.

2 I then drew guidelines for the scaly skin along its neck *(above centre).*

3 To complete the bird, I used bold strokes with a 4B pencil *(right).*

31

Looking at Features

When drawing fantasy figures, often the only things that make them different from 'real-life' ones are the details. Changing hands, feet, ears, noses and eyes are perhaps the most obvious ways to alter the characters that we draw. Here are a few examples to illustrate this.

Hands

An imaginary character's hands do not have to conform by having five fingers or well-manicured nails, but they should be suited to its habitat and behaviour. For example, does your creature need claw-like nails for climbing trees or digging, or hands covered in hair to protect them from the rocks of its frozen mountain lair?

Feet

There are a few questions you should ask yourself before drawing your creature's feet. How heavy is the creature they are to support? What is the nature of the terrain? The answers should indicate whether you give it hair or scales and whether the legs are bird-thin or wide and muscular. If you have any doubts, the animal kingdom can provide you with endless possibilities.

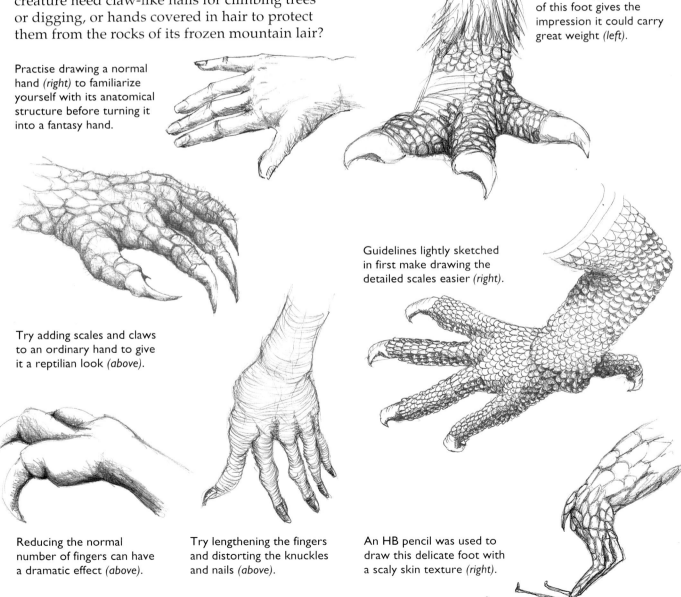

Practise drawing a normal hand (right) to familiarize yourself with its anatomical structure before turning it into a fantasy hand.

The solid appearance of this foot gives the impression it could carry great weight (left).

Try adding scales and claws to an ordinary hand to give it a reptilian look (above).

Guidelines lightly sketched in first make drawing the detailed scales easier (right).

Reducing the normal number of fingers can have a dramatic effect (above).

Try lengthening the fingers and distorting the knuckles and nails (above).

An HB pencil was used to draw this delicate foot with a scaly skin texture (right).

Ears

Ears are the most frequently changed appendages in fantasy art, and can have a dramatic effect on your picture. Try using the ears shown below to create four different impressions with the same basic face.

Careful observation of the anatomical structure of the ear is very important *(right)*.

Care must be taken to show the detail of the soft tissue as the ear is distorted *(left)*.

The detail in this elf's ear is built up using a 4B pencil *(right)*.

The shape of the ear can go as far as your imagination takes you. Here heavy shading accentuates its leathery, membranous appearance (left).

Eyes

Eyes, they say, are the windows of the soul, and perhaps they are the feature that has the greatest impact in our drawing. Again try imagining each of the pairs of eyes below with the ears on the left and you will see what a startling effect the different combinations make.

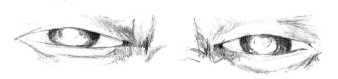

Lids and pupils produce a variety of looks …

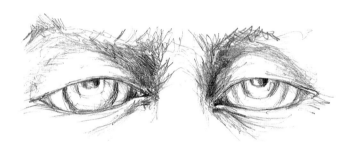

from a sleepy, tired gaze …

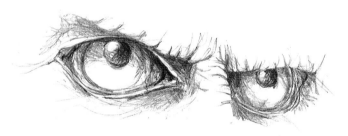

or a piercing stare …

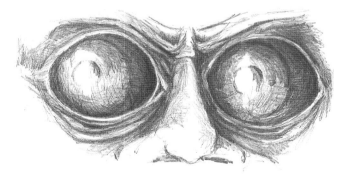

to huge eyes that are made to see in the dark.

Noses

Fantasy characters are often endowed with the most unusual noses. Goblins, elves, gnomes, giants – all in turn have been given an amazing proboscis. As with hands, eyes and ears, noses must be adapted to the job they have to do – imagine what your character's nose would look like if it had anything other than air to breathe.

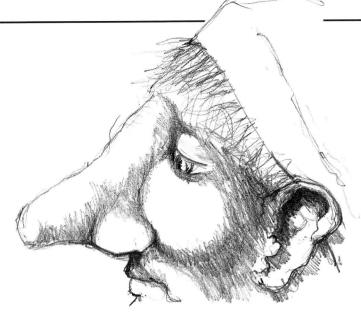

Here I have drawn a bulbouse nose, building up light and shadow with a 2B pencil *(right)*.

A slight variation on the same lines can give a different look *(left)*.

Somehow hooked noses *(left)* seem very suitable for gnomes and wizards.

Deep-set eyes seem to need a large nose with wide nostrils to balance the face *(above)*.

Mouths

You should be clear in your mind how your creature talks and how it takes in food before you decide what kind of mouth to draw. The type of food your fantasy character eats will determine the sort of teeth he has.

As an interesting exercise, mix and match different features to create two different faces.

A snarling, carnivorous mouth is made more terrifying by its dark, cavernous inside *(left)*.

Discover what a dramatic picture you can create by putting together some of the features shown in this section *(below)*.

The menace in this savage leer is accentuated with the use of light and shadow *(above)*.

This looks like an ordinary mouth *(above)* …

… until it opens in a rather sinister smile revealing large, gappy teeth *(left)*.

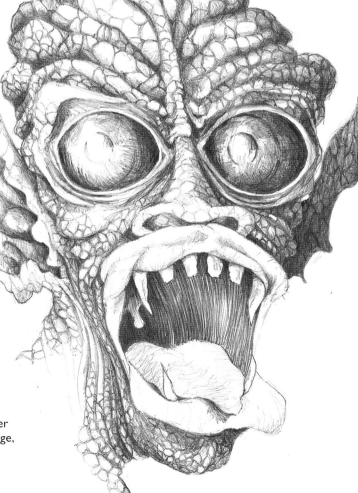

Magical Trees

Tree magic runs through a great deal of fantasy from the earliest folk tales of the Green Man through to the Ents in Tokien's *Lord of the Rings*. Trees can assume many personalities; here I have illustrated this by creating a tree warrior. The organic shapes of trees lend themselves perfectly to this kind of characterization.

Finding reference material
There are endless examples of gnarled old tree trunks in country lanes and hedgerows. Even if you live in a city, there are opportunities to draw trees in streets and parks. It is worth taking the time with your sketchbook to gather material for your tree drawings.

Artist's Tip

Try taking a rubbing from a tree with a soft pencil and a piece of cartridge paper to see the patterns and textures in the bark.

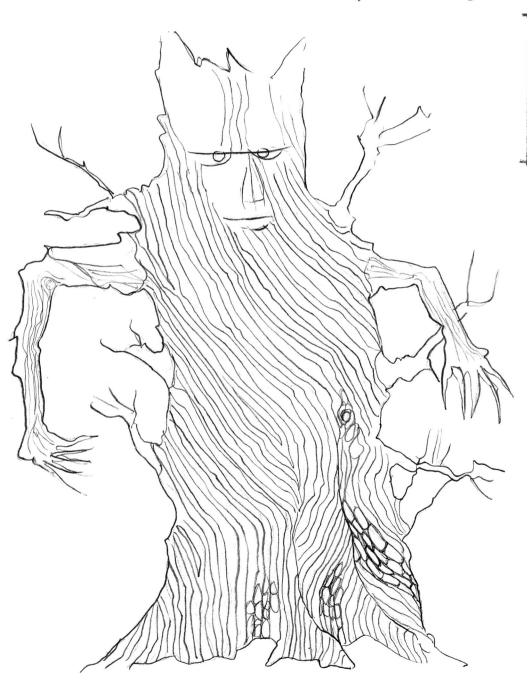

The preparatory sketch for the drawing opposite *(left)*. Trees grow upwards out of the ground and this should be reflected by the growth lines and patterns in the bark.

Creating a tree character

First draw the outline of a tree, as I have on the opposite page, using some of the lower branches to represent arms. Where the roots enter the ground they can be altered to give the impression of feet. It's best to draw in the growth lines of the bark lightly before trying to put in any ivy and creepers clinging to the surface of the tree.

I have done a separate drawing of the ivy to show how the upper tendrils become entangled and so create the beard of the tree warrior in the finished picture. Working over the surface gently with a 4B pencil helps to create the depth of the contours of the twisted trunk.

I used a soft 2B pencil to create the texture of the bark and give the final drawing a sense of movement *(below)*.

Sketching out the details of the ivy before adding it to your final drawing is a great help *(below)*.

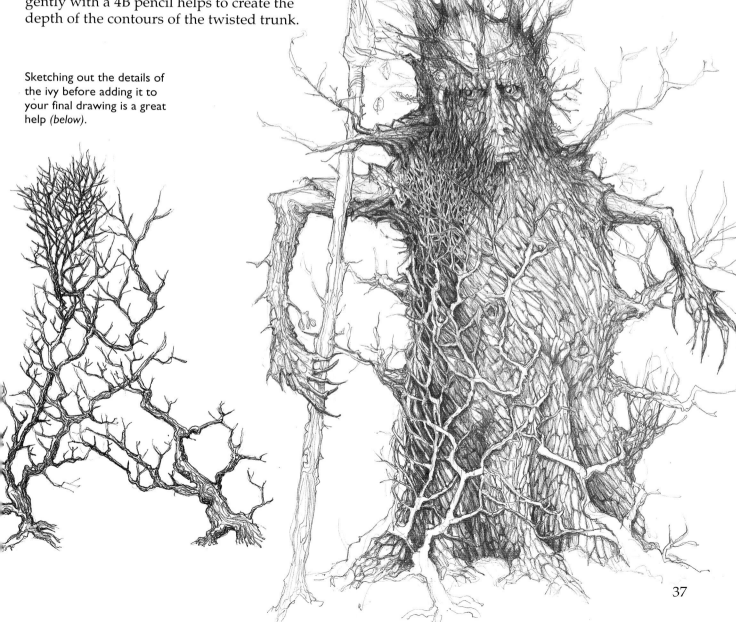

Angels and Demons

Angels

Angels have enjoyed mixed popularity during their long history, from the fearsome images of medieval times to the altogether gentler images of today.

If you don't know how to begin drawing an angel, there is plenty of reference material to look out for in churches and in the spectacular, monumental sculptures in churchyards.

In the step-by-step drawings of the angel below, I began with a rounded head and drew the wing showing the directional flow of the feathers.

You will notice that the face is very much that of a child with wide-set eyes, small nose and gentle expression; giving your angels a child's facial proportions will make them look benign. The ornamental surround was drawn working from the inside out.

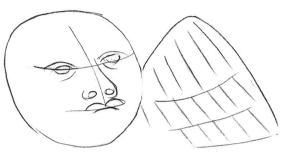

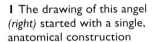
1 The drawing of this angel *(right)* started with a single, anatomical construction

3 The position of the wing and feathers and the details of the face were then sketched in *(below)*.

2 The details of the hair were lightly sketched using an HB pencil *(above)*.

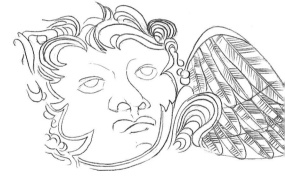

4 I did the final drawing *(right)* with a technical pen, gradually building up the shaded areas with stippling.

Demons

The demons illustrated on this page are copied from gargoyles which were originally carved to keep evil out. Note how their form is exaggerated – their foreheads heavy and ponderous, their eyes enlarged, and their mouths and tongues out of proportion. The impression they give is clearly one of brooding and menace – which is all in stark contrast to the gentleness of the angels.

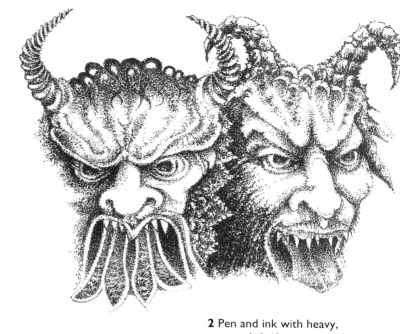

2 Pen and ink with heavy, textured shading was used in the finished drawing to give these demons their dramatic appearance *(above)*.

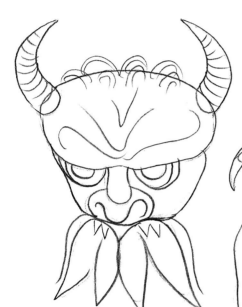

1 The demons start off as a mask-type sketch. At this stage, they are flat, two-dimensional shapes *(above)*.

A foreshortened arm, staring face and snarling mouth give the impression that this demon is really reaching out for you *(right)*.

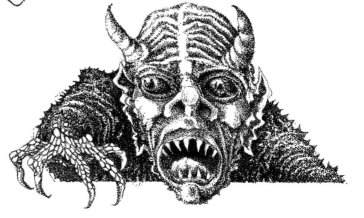

Wizards and Magicians

A book of fantasy would not be complete without its complement of wizards and magicians. From Merlin to Gandulph they have created so much magic.

Traditionally wizards and magicians are able to be malign or gentle, fighting for the powers of good or evil. They are most often portrayed as elderly, bearded gentlemen wearing voluminous gowns and tall, pointed hats.

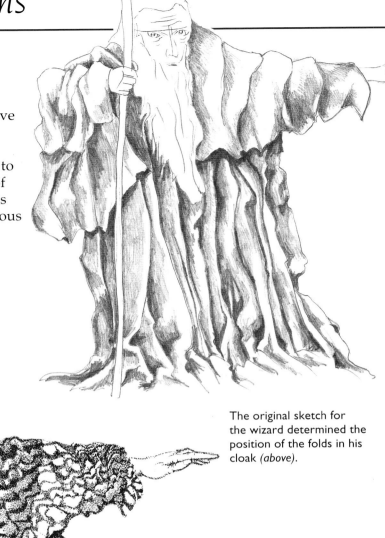

The original sketch for the wizard determined the position of the folds in his cloak *(above)*.

Texture, light and shade have been put in with pen and ink in this finished drawing, giving the magician s cloak an almost bark-like appearance *(left)*.

Flowing fabric

Having sketched out your magician, it is worth taking a moment to look at how to draw the folds in his flowing cloak. Folds in fabric naturally hang downwards, only creasing and spilling out when they reach the ground.

Fabric will follow the contours of the body it clothes. By shading the inner part of each fold you can give the impression of depth to the outfit. A heavy fabric will give fewer, deeper folds than a very light cloth.

Making magic

You can easily build up a sense of mystery and magic by adding various pieces of paraphernalia such as books, skulls, crystal balls, hour-glasses, pestles and mortars, phials and herbs, etc. By placing the wizard below in a vaulted chamber, I have added a feeling of secrecy to the picture.

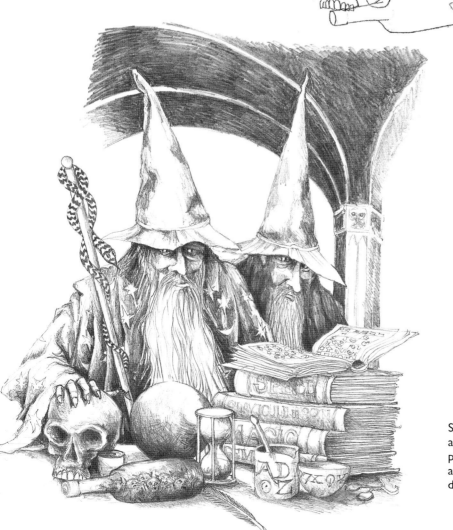

Take a moment to think about what a magician might have in his tower — skulls, books of spells, potions, etc. Details such as these will give the picture added interest and meaning *(above)*.

Strong light and shadow applied with a soft **4B** pencil defines and enriches all the details in the finished drawing *(left)*.

Movement

There are many ways to express movement in your pictures, from a gentle gesture to something quite dramatic. The pictures below show the changes that occur when a stationary dragon, with a rider, begins to move.

In the first drawing on the right, the dragon is standing quite still with his weight spread evenly over both feet, and the rider sitting relaxed in the saddle. Notice how the reins are loose and the spear lowered.

Speeding up

As the dragon begins to move forward, he stretches out his neck and lowers his body, taking the weight on his leading leg while the toes of the other foot push up from the ground. As his wings start to beat in preparation for flight, he becomes slightly elongated and his tail begins to trail behind him. The rider, meanwhile, has gripped the reins more tightly so that they are taut; he leans forwards with his spear raised to keep his balance as the dragon accelerates.

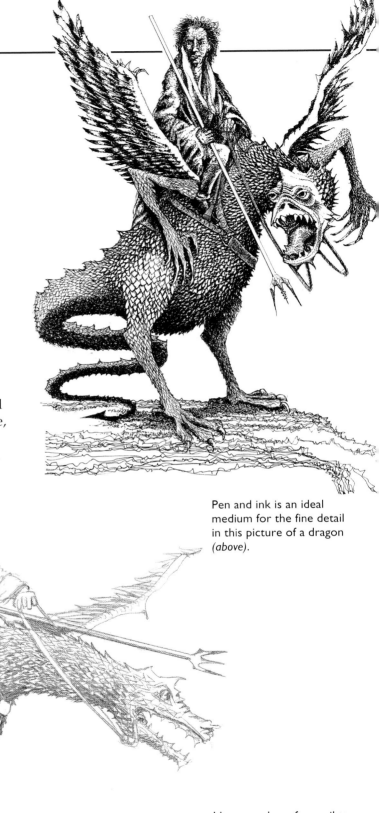

Pen and ink is an ideal medium for the fine detail in this picture of a dragon (above).

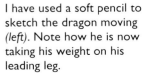

I have used a soft pencil to sketch the dragon moving (left). Note how he is now taking his weight on his leading leg.

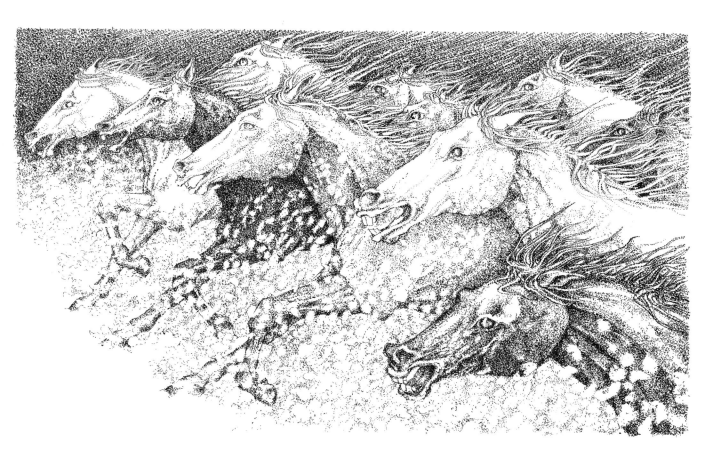

Wild horses
In the pen-and-ink study of horses galloping through the snow, I have drawn their manes streaming out as their heads and necks stretch forwards, while snow flies backwards over their shoulders. These strong, backward diagonals give a powerful sense of forward movement.

Snarling gargoyles
In this study of medieval gargoyles, sharp contrasts in shadow coupled with their snarling mouths and outstretched claw give the impression that they have suddenly turned to attack something.

This picture of horses heads *(above)* is built up with a single repeated image. The movement is created by the exaggerated flying manes and swirling snowflakes.

Using a dip pen and ink on line and wash board, I have given these gargoyles a sense of menace through the use of dramatic light and shadow *(below)*.

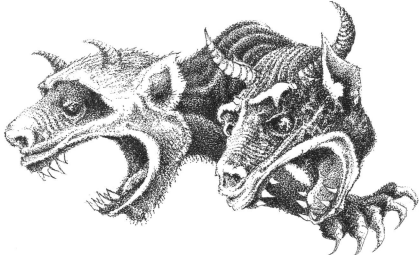

Sketching

Carrying a sketchbook is an excellent habit to get into – most artists have one nearby for that moment when they spot something unexpected or unusual which they want to capture quickly on paper. Although we are unlikely to come across the stuff of our fantasies roaming the city streets or wandering loose in the countryside, that is no excuse for leaving your sketchbook and pencils at home. Getting into the habit of sketching as often as you can will dramatically improve your drawing and observational skills.

Practice makes perfect

The easiest way to start is to use your sketchbook for a few minutes each day. Set yourself simple tasks, such as drawing your shoes where you kicked them off, the clutter of personal things on your bedside table, your friends when they drop round to see you. Draw the trees or flowers in your garden, and the houses near where you live. In this way, you will quickly build up a set of invaluable references that you can use in your fantasy art.

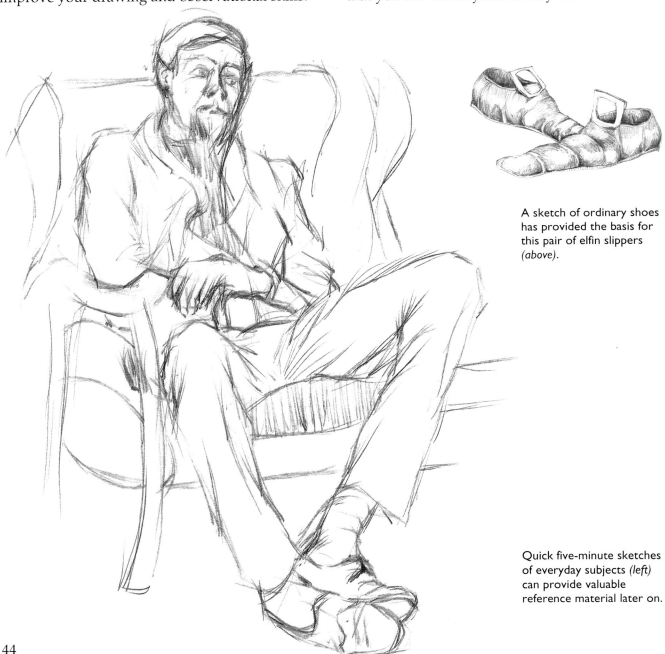

A sketch of ordinary shoes has provided the basis for this pair of elfin slippers (*above*).

Quick five-minute sketches of everyday subjects (*left*) can provide valuable reference material later on.

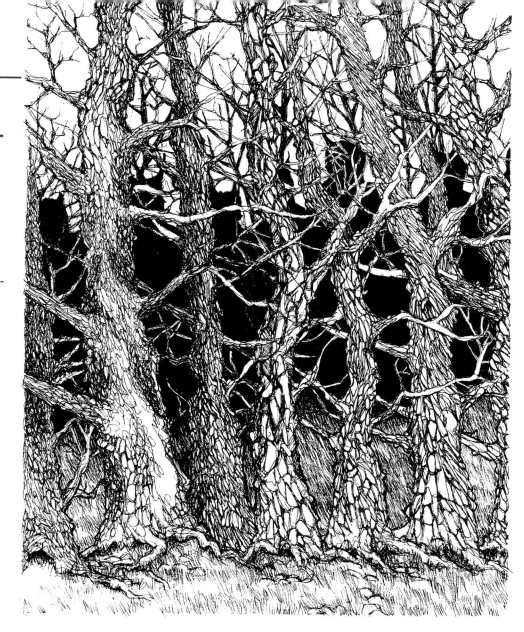

Artist's Tip

Carry a sketchbook with you at all times — you never know when you might see something that would be ideal for use in your fantasy drawings.

A row of bare, winter trees captured in your sketchbook can later become the impenetrable forest of your fantasies *(right)*. Here I have emphasized their detail — and added a feeling of menace — with heavy shading in the background, suggestive of horned figures.

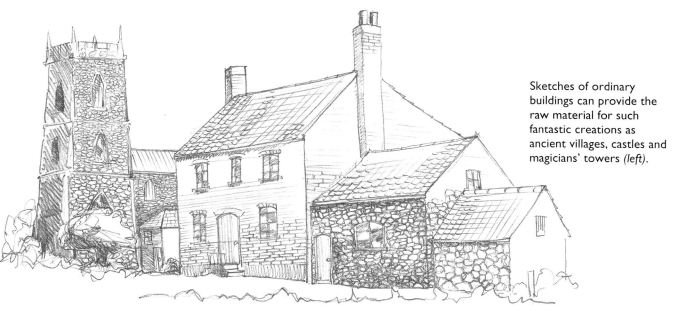

Sketches of ordinary buildings can provide the raw material for such fantastic creations as ancient villages, castles and magicians' towers *(left)*.

Castles and Citadels

Whether it is soaring towers, or castles with sheer walls, battlements and spires you wish to draw, consider first who will be living there and what the building's function will be. For example, a fortress built to resist a siege or guarding a harbour will look very different from a magician's round tower standing perched above a gorge. The first might have thick, iron-studded doors, a drawbridge and narrow window slits, while the magician's tower may well have an observatory for studying the stars and endless spiral stairs.

Both of these will look very different from an enchanted palace with galleries and balustrades, manicured lawns and topiaried hedges.

Building materials

The building's age will determine what it is made of. Medieval fortresses, for example, would require huge blocks of quarried stone while a fortress from an even earlier period might have been built from massive timbers within a series of fortified earthworks.

Breaking down the shapes

Whatever fantastical castle or citadel you imagine, it is a good idea to break it down into simple geometric forms before attempting to draw. The cylinder, the cone and the cube shown here are the three shapes you will find most useful and it is well worthwhile spending some time practising how to draw them.

This city perched on a rocky pinnacle *(below)* has been built up from the three basic shapes shown on the left.

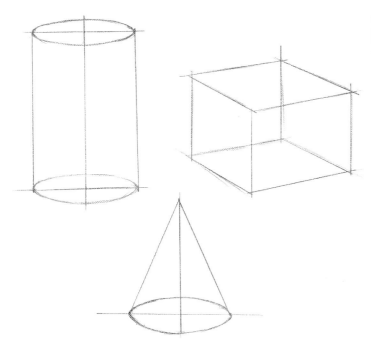

The basic shapes you will need to create fantasy buildings are a cylinder, a cube and a cone *(above)*.

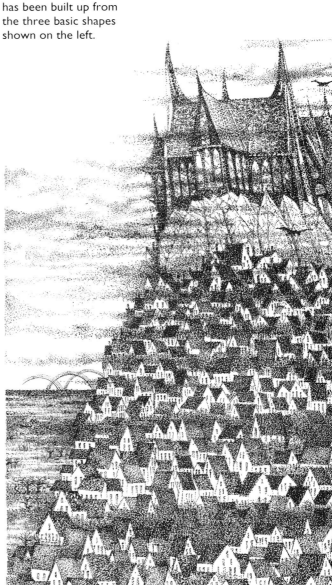

Turretted tower

A magician's tower looks a difficult project but it is really only three large cylinders for the main towers, two smaller ones for the upper chambers and five cones of various sizes for the roofs. The door is depicted as a heavy, wooden one and the steps are hewn out of the rock upon which the tower has been built.

The second stage in this drawing is to lightly sketch in the cylindrical lines where the bricks are to be drawn, bringing them slightly closer together as they reach the top of the tower because of the perspective. Remember to stagger the bricks as you work up from the bottom.

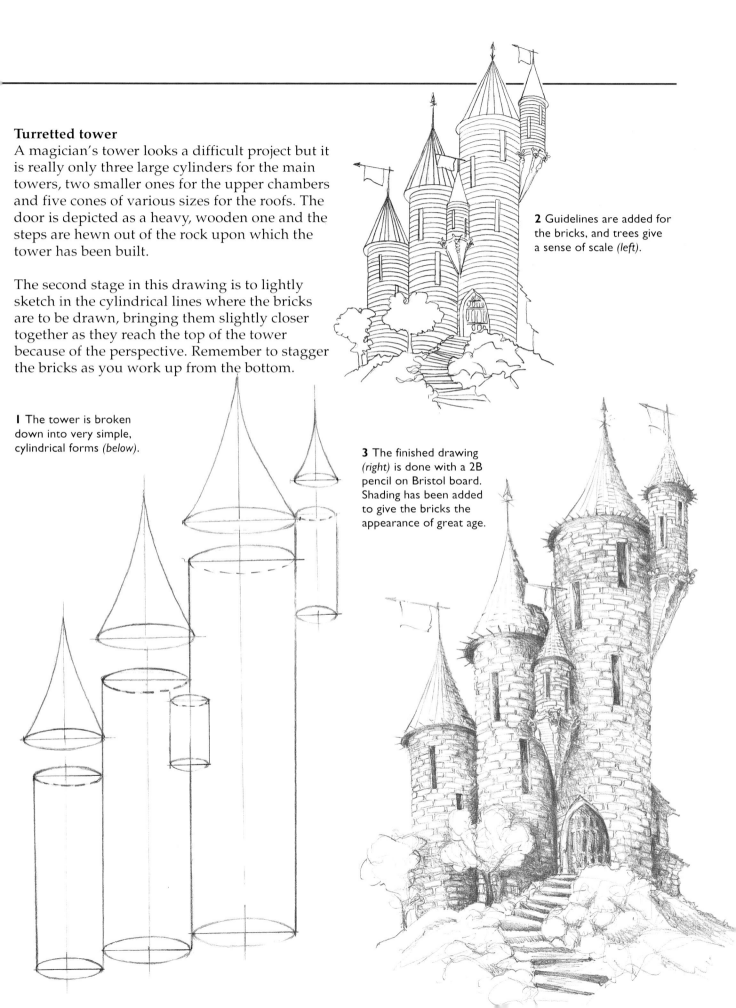

2 Guidelines are added for the bricks, and trees give a sense of scale *(left)*.

1 The tower is broken down into very simple, cylindrical forms *(below)*.

3 The finished drawing *(right)* is done with a 2B pencil on Bristol board. Shading has been added to give the bricks the appearance of great age.

Drawing cube-shaped buildings

Representing three-dimensional, cube-shaped buildings on a flat, two-dimensional surface is not as difficult as it first appears. There is a simple formula to get you started: all vertical or horizontal lines, and those joining them, are parallel. In the accompanying illustrations, horizontal lines are 'A,' vertical lines are 'B', and oblique lines joining them are 'C'.

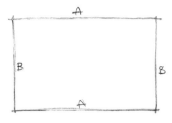

I Draw the front of your building in a simple oblong *(left)*. Remember that 'A' represents the horizontal and 'B' represents the vertical lines.

2 Draw the back of your building slightly above and to the left of your first oblong *(right)*. Imagine that your house is made of glass so that you can see all the construction lines.

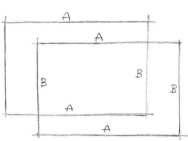

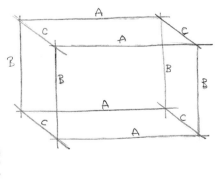

3 Draw in the sides of your building – lines 'C' *(left)*, making them parallel. If you want to adjust your lines to be in true perspective, do this now.

This easy formula will provide your basic cube shape. However, to be in true perspective, you may want to adjust the lines so that they taper inwards the further away they are from you.

You can see this effect clearly in the first drawing of the fortress on the right. You will see how the sides of the building taper inwards more and more the higher they go. It is this exaggerated perspective effect that tells us that our viewpoint is low down – that we are very small, and that the fortress is very high, towering up above us.

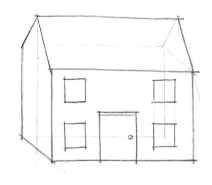

4 Add roof, and any doors and windows that you wish and erase any unwanted construction lines *(left)*.

Artist's Tip

The outlines of details such as windows or doors will always be parallel with the outlines of the walls in which they are placed.

A castellation like this *(below)* is made up of basic cylinders and rectangles.

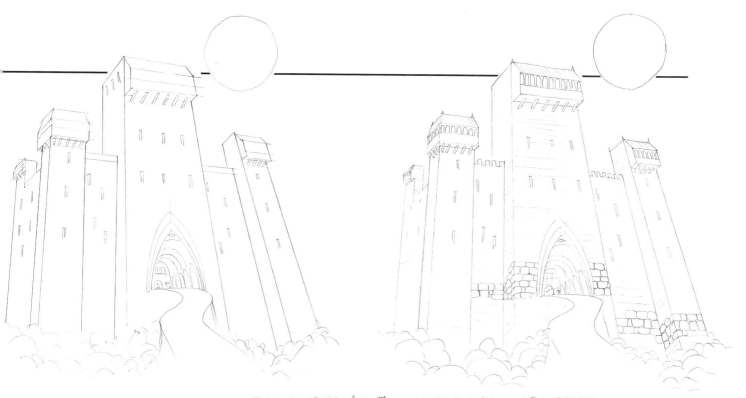

1 & 2 Establish your
construction lines before
beginning on the detail
(above). Take care also
to draw in the guidelines
for the stone blocks the
castle is constructed from
(above right). Remember
the further they are away
from you the smaller they
will appear.

3 In the final pencil drawing
(right), bold contrast with
soft 4B pencil makes the
fortress stand out against
the night sky.

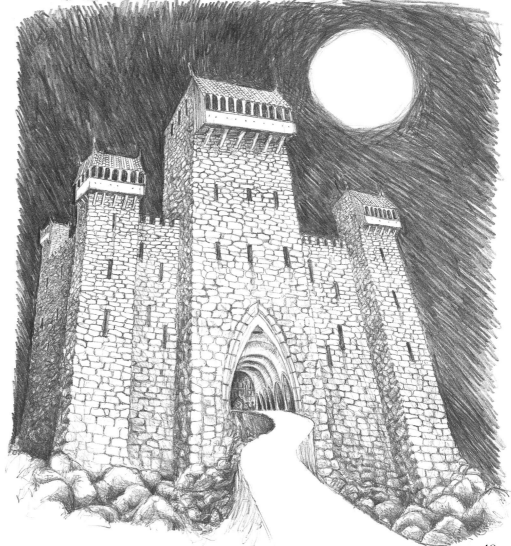

Chariots and Galleons

Modes of transport can be as diverse as the people and worlds that fill your pages, but on the whole traditional fantasy uses vehicles that appear to come from an earlier time than ours.

Land travellers
Below, I have chosen to show you a chariot with a spear stand. As always in fantasy art, bear practicality in mind – even if your creations do come from your imagination, they should still look as if they could work in 'real life'. A vehicle such as this, for example, would depend upon speed for its effectiveness, and therefore would be constructed from a material that was light and flexible; I have chosen to make my chariot from wickerwork which is durable but light.

My other drawing, in complete contrast, is a magical coach. Needing neither speed for escape nor armourplating for defence, it can therefore be made of the most fantastical and least practical of materials – glass.

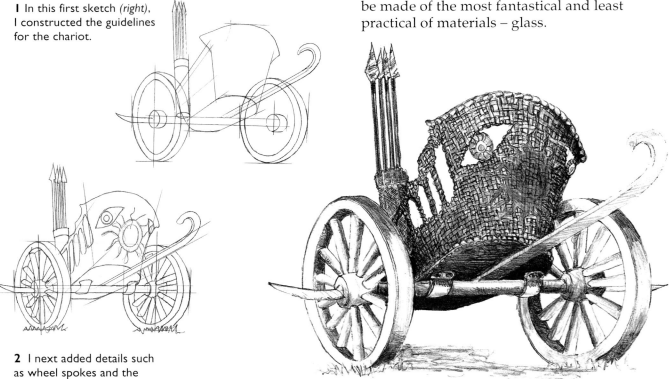

1 In this first sketch *(right)*, I constructed the guidelines for the chariot.

2 I next added details such as wheel spokes and the decorative designs on the front *(above)*.

3 To complete the drawing, I filled in the details such as the wickerwork and shading *(above)*. I used coloured pencils for the finished piece.

In contrast to the chariot above, the pen, ruler and compass used to draw this coach *(right)* emphasize the delicacy of the glass from which it is made.

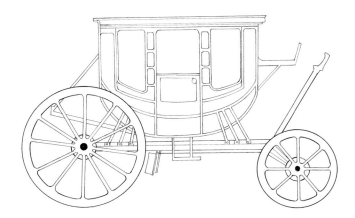

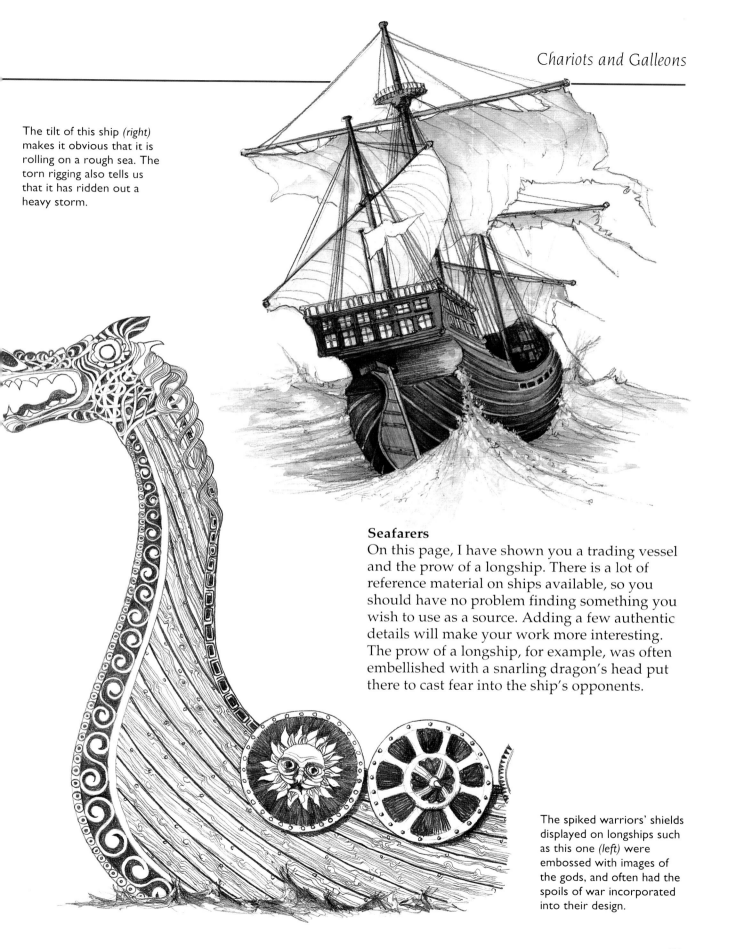

The tilt of this ship *(right)* makes it obvious that it is rolling on a rough sea. The torn rigging also tells us that it has ridden out a heavy storm.

Seafarers

On this page, I have shown you a trading vessel and the prow of a longship. There is a lot of reference material on ships available, so you should have no problem finding something you wish to use as a source. Adding a few authentic details will make your work more interesting. The prow of a longship, for example, was often embellished with a snarling dragon's head put there to cast fear into the ship's opponents.

The spiked warriors' shields displayed on longships such as this one *(left)* were embossed with images of the gods, and often had the spoils of war incorporated into their design.

Drama and Atmosphere

Drama and atmosphere can be conveyed by the pose and expression of your figures, the intensity of the light, and the depth of shadow.

In the picture on this page, I have drawn a heavily tattooed face peering through a screen of ivy. The face is full-frontal and the eyes appear to be staring directly at you. The use of the light and shadows on the face creates a startling – but not terrifying – impression. In fact, the picture is of a watcher who holds no particular menace.

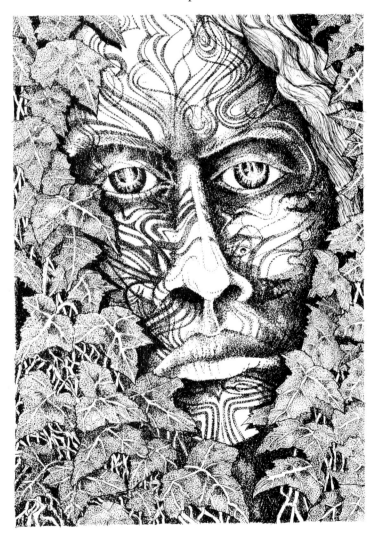

The complexity of this drawing (above) was best conveyed in pen and ink on a line and wash board.

I used an HB pencil to work out the position of the ivy surrounding the face and the depths of light and shade (above).

A sense of menace

In contrast, here is a picture of a kneeling angel which is full of threat. Again his eyes are staring directly at you; however his mouth is drawn into a snarl and his right arm is raised with its fist clenched. Although the figure is kneeling, he appears to be almost in a crouching position and about to spring. His wings have deep shadows which are magnified onto the wall behind; their darkness and size emphasizes their power.

Artist's Tip

Strong contrasts of light and shade can greatly add to the dramatic impact of a picture.

Pen and ink seemed the ideal medium for the detail in the angel's wings and for the depth of shading on the wall behind him.

Dramatic shadows

To create the drama in this picture, the head has been tilted back so that we are viewing the figure from slightly below. Although I have not used shadow behind the head to emphasise it, the lack of any background focuses the attention directly onto the figure. Heavy shading in the mouth coupled with light, staring eyes draws the eye and convey the subject's pain.

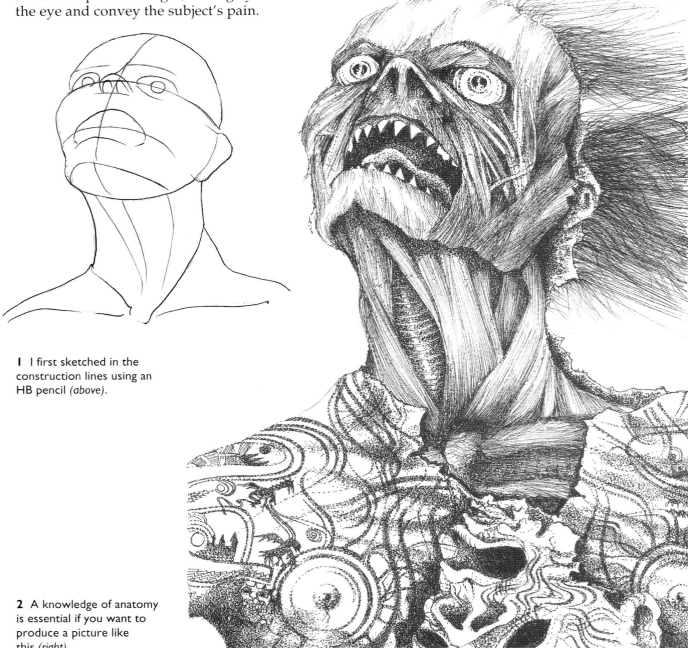

1 I first sketched in the construction lines using an HB pencil (*above*).

2 A knowledge of anatomy is essential if you want to produce a picture like this (*right*).

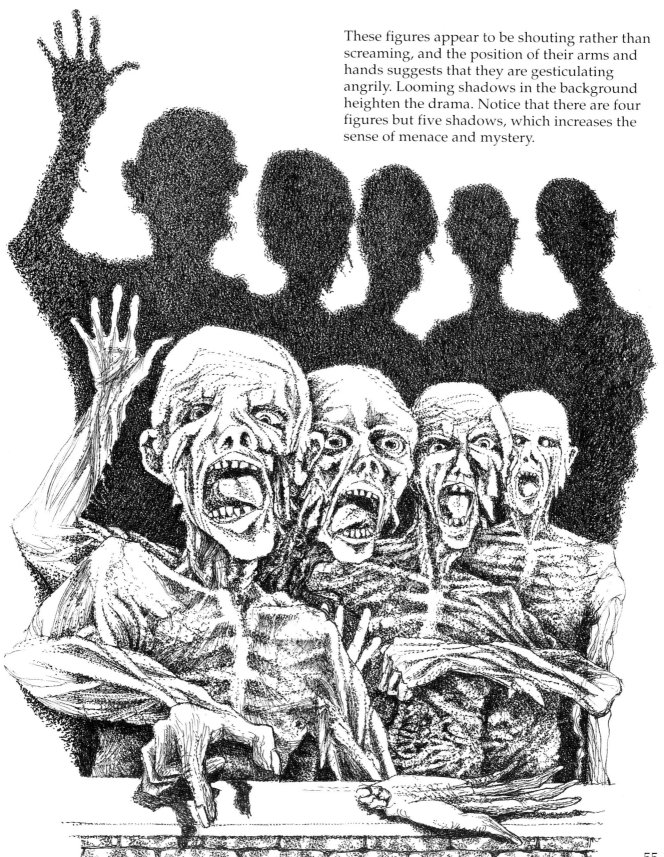

These figures appear to be shouting rather than screaming, and the position of their arms and hands suggests that they are gesticulating angrily. Looming shadows in the background heighten the drama. Notice that there are four figures but five shadows, which increases the sense of menace and mystery.

An air of expectancy

The atmosphere in the picture below is created with very little movement. The houses on the edge of the water are obviously all inhabited as the smoke from their cooking fires is curling up away from the top of the roofs. Superficially, the scene appears peaceful, but why is the figure in the foreground peering out from between the reeds? Clearly, something is about to happen that is going to upset the apparent calm.

Scene of peace

The picture opposite is similarly peaceful, but without the sense of expectancy of the scene below. Here, people are taking refuge from a flood and sheltering in a large tree. The feeling is not of panic and movement but of patient waiting and resignation to fate. The tree itself takes centre stage here; it fills the page, giving a sense of strength and permanence as it shelters the small figures in its branches.

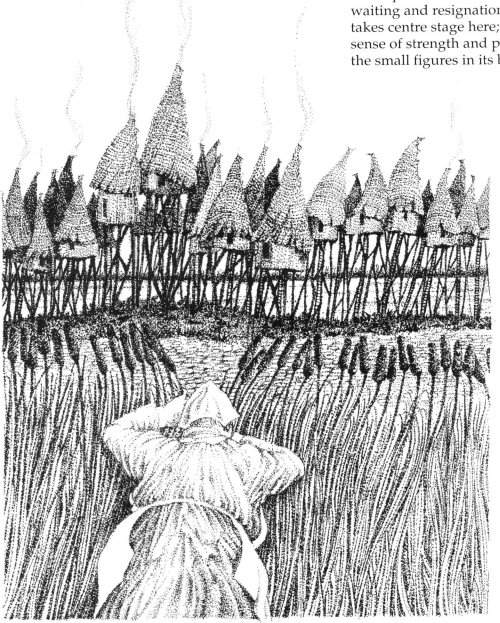

In this pen-and-ink drawing note the similarity between the stilts with their strange, conically shaped houses and the movement in the bulrushes that the woman is looking through *(left)*.

This pen-and-ink drawing of people sheltering from the flood in the branches of the great oak trees is an exercise in scale *(opposite)*.

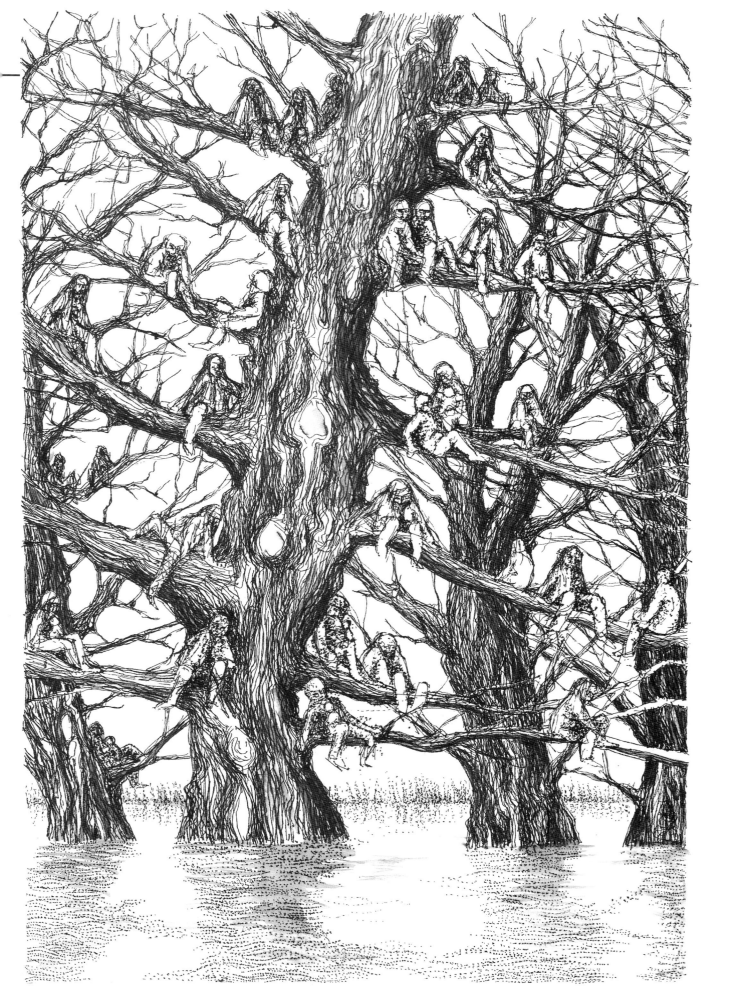

In Setting

Landscapes and backgrounds can provide vital information which gives more meaning to your picture. For example, a scene of houses raised on stilts would have little meaning without the marshes with their bulrushes in the foreground.

Seasons and weather

Backgrounds can suggest other information, too. Bare branches or blossom or fruit on the trees give an indication of the time of year; the length and depth of the shadows describes the time of day. The direction of curling smoke gives a clue about the wind and weather.

Using shadow

Including heavy shadow around selected objects draws the viewer's eye and emphasizes the focal points in your picture.

Settings are especially important in fantasy art because they give imaginary characters a context in which to act out their stories. The same bird in different settings (*below* and *opposite*) shows the continuity and development of this particular story.

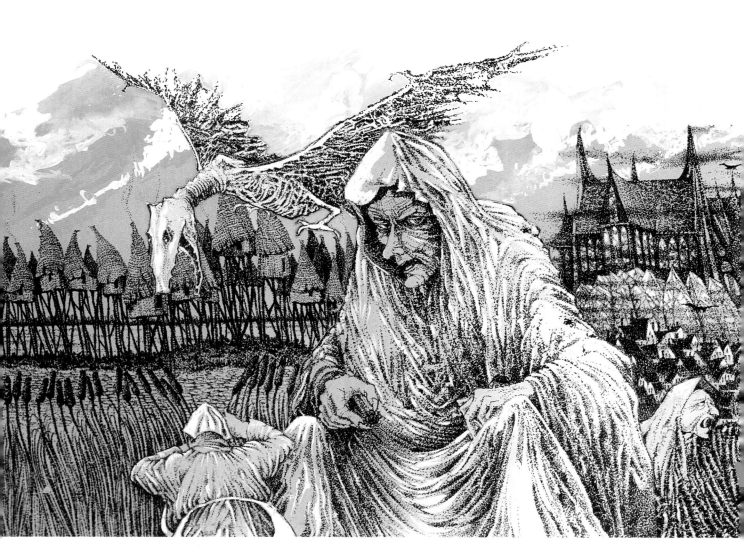

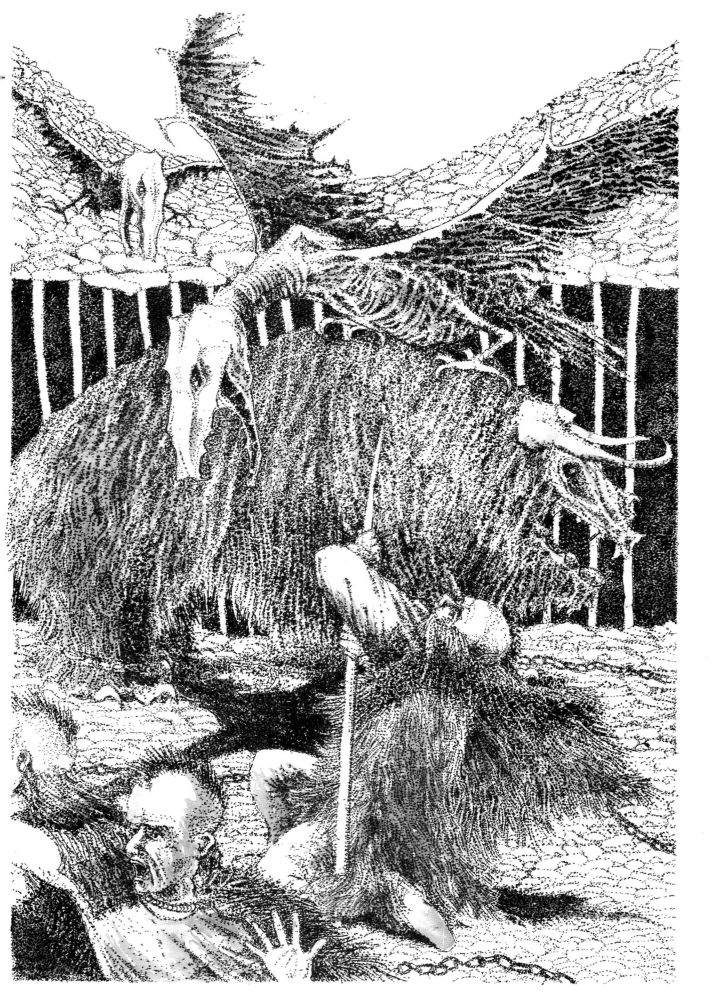

Creating Maps

No book about fantasy art would be complete without a small section on maps. A map provides a setting in which your imaginary people and creatures can exist, thus making them seem more real. Maps are fun to draw, too.

Types of map

There are many ways to draw a map. The earliest 'ribbon' maps were drawn on parchment scrolls; they often followed a road or a narrow strip of known countryside and took the traveller from one place to another. In contrast, there is the modern road atlas which is accurate to the tiniest detail.

Maps became a work of art during the Middle Ages and contained many wondrous beasts and sea monsters. In fact, the explorers often believed that these creatures really lived beyond their known world.

Drawing a map

When drawing a map, it is best to start by roughly sketching in the main features such as roads, forests, mountain ranges and oceans to check that they are in proportion. Castles, towers and villages can then be added. The last – and perhaps the most enjoyable – part will be to add the monsters and fantastical creatures in any spaces that are left.

At first glance, this detail of a fantasy map *(below)* looks relatively ordinary, until you spot the place names.

A fantasy map *(opposite)* which is more like a bird's-eye view, filled with forests, mountains, and imaginary places and creatures.

Artist's Tip

Once you have lightly sketched in the main parts of your map, technical drawing pen is ideal for adding in all the fine detail.

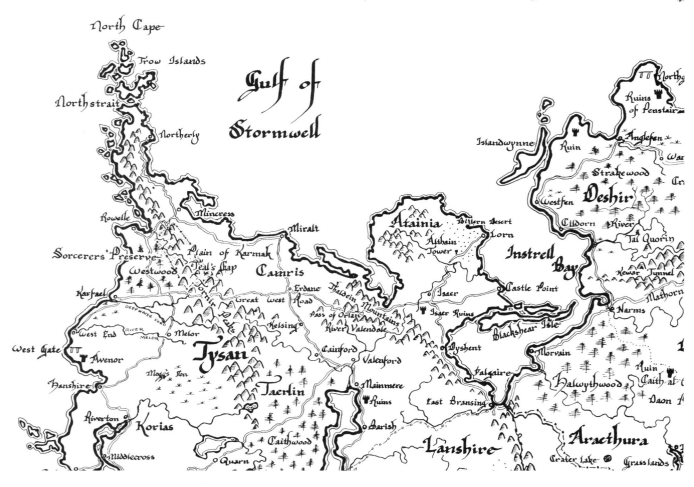

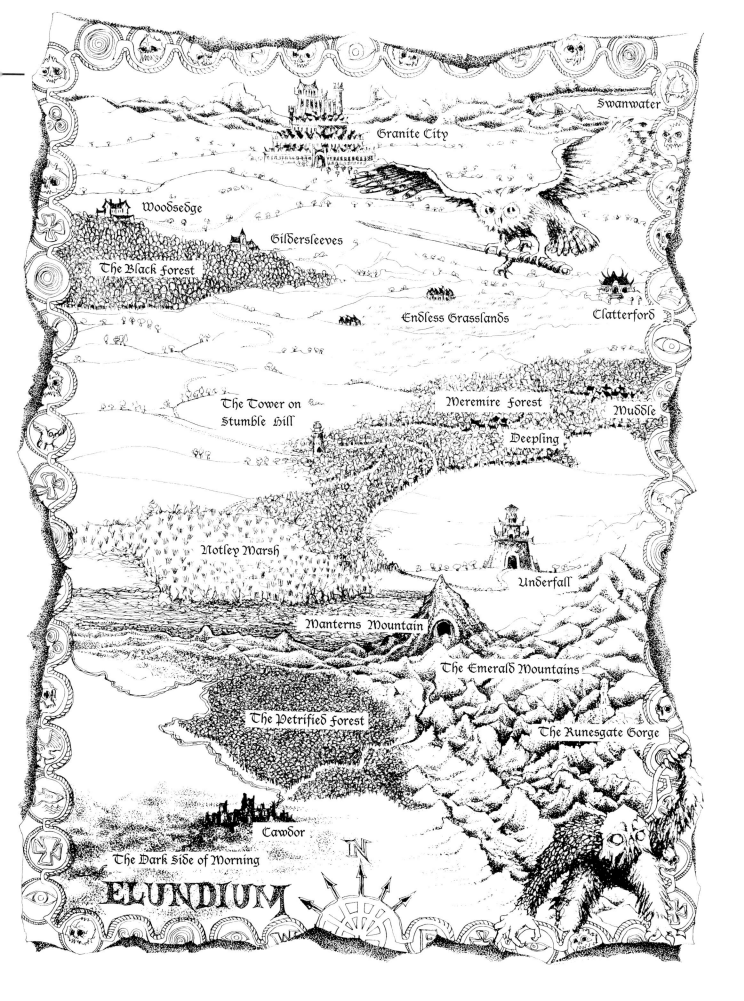

Swanwater

Granite City

Woodsedge

Gildersleeves

The Black forest

Endless Grasslands

Clatterford

Meremire forest

Muddle

The Tower on Stumble Hill

Deepling

Notley Marsh

Underfall

Manterns Mountain

The Emerald Mountains

The Petrified forest

The Runesgate Gorge

Cawdor

The Dark Side of Morning

ELUNDIUM

N

Working from References

There is a wealth of visual reference available that can provide the basic information you need. However, unlike an artist in another genre, the fantasy artist has to be able to look at references and then go one step further. Whereas most drawing involves studied observation, fantasy drawing demands a different approach. It is not enough to draw what you see: you have to be able to take a leap of the imagination.

Transforming the ordinary
As you can see from these two photographs of a ruined Norfolk church, I have used their basic structure as no more than a starting point. What was a church is now a broken-down, ivy-clad tower, its dark, hollow interior housing creatures of the night. I have even turned the tree on the right-hand side of the first photograph into a guardian of the tower with a spear, waiting to attack the beasts should they venture out.

It is making such leaps of imagination that inspires the fantasy artist. I hope that I have inspired your fantasies in this book.

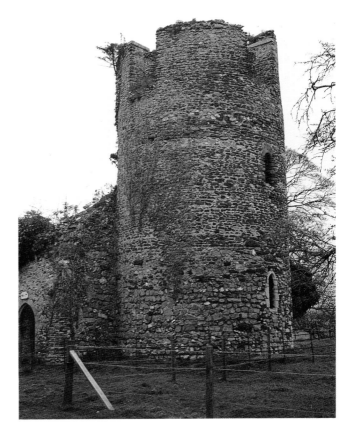

I chose these photographs of a local ruined church *(above* and *below)* for their brooding atmosphere.

The detail of the ivy and the dark doorways made this photograph an ideal choice for the picture I had in mind *(right)*.

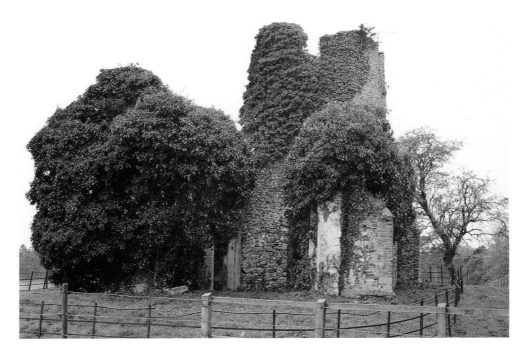

You can see that I have
selected pieces from both
photographs to create my
picture of the tower.
The finished drawing was
done in soft pencil on
cartridge paper.

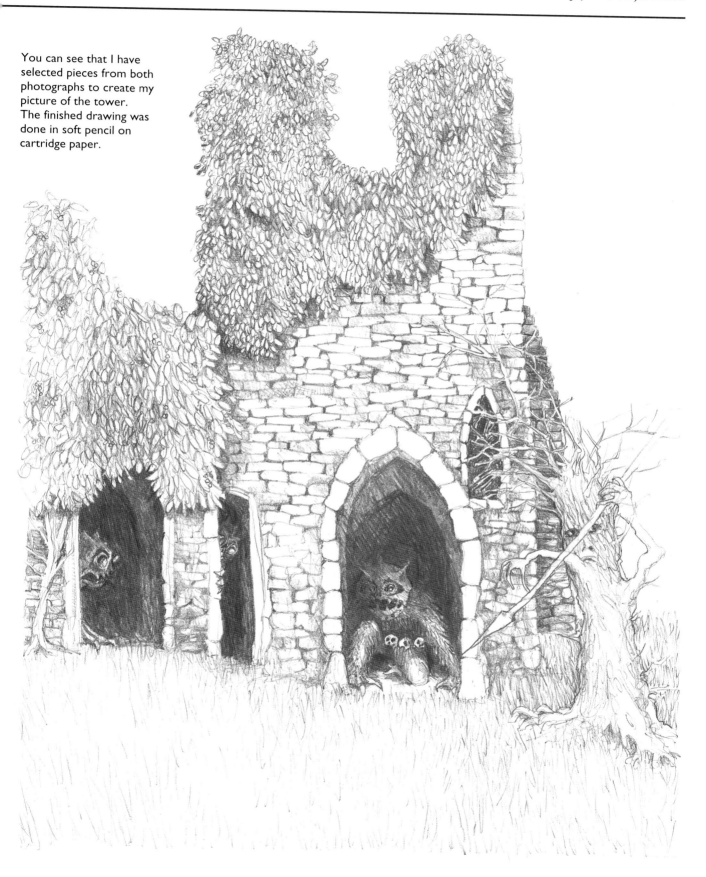

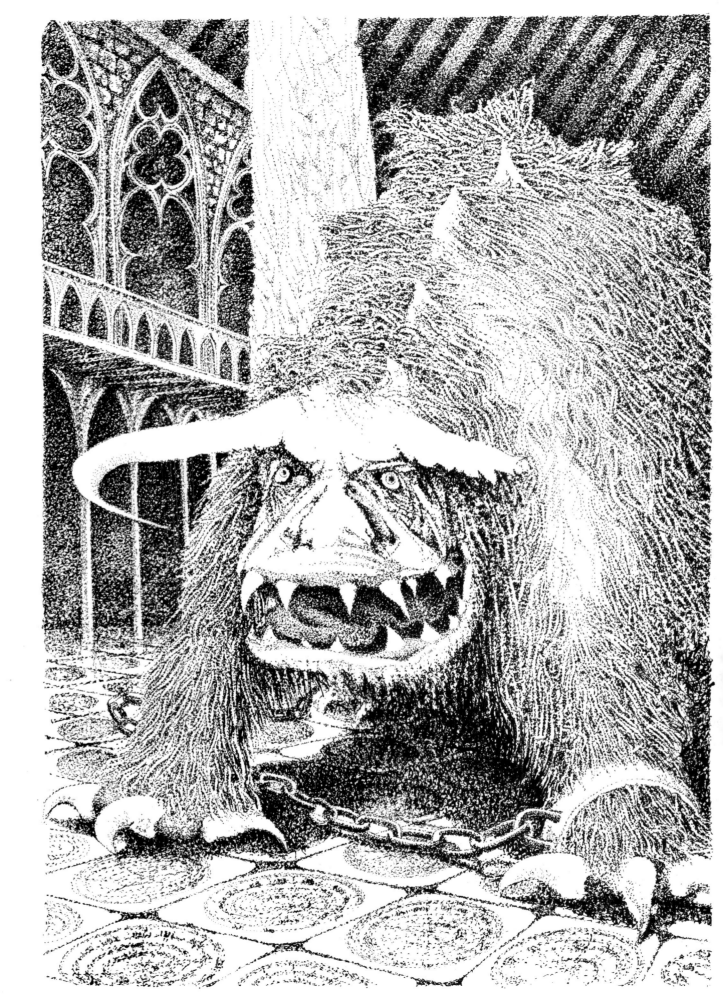